CIVILISING
CALIBAN

CIVILISING CALIBAN

The Misuse of Art 1875–1980

Frances Borzello

Routledge & Kegan Paul
London and New York

First published in 1987 by
Routledge & Kegan Paul Ltd
11 New Fetter Lane, London EC4P 4EE

Published in the USA by
Routledge & Kegan Paul Inc.
in association with Methuen Inc.
29 West 35th Street, New York, Ny 10001

Set in 10½/12 point Sabon
by Hope Services, Abingdon, Oxon
and printed in Great Britain
by T. J. Press Ltd,
Padstow, Cornwall

Library of Congress Cataloging in Publication Data

Borzello, Frances.
Civilising Caliban.

Includes index.
1. Art and state—Great Britain. 2. Art and
society—Great Britain—History—19th century.
3. Art and society—Great Britain—History—
20th century. 4. Great Britain—Cultural policy—
History—19th century. 5. Great Britain—Cultural
policy—History—20th century. I. Title.
N8846.G7B67 1987 701'.03 87–4657

British Library CIP Data also available

ISBN 0–7102–0675–5

For Anna and Nicholas

Contents

Illustrations

Acknowledgments

My thanks to family and friends for listening patiently, to Will Vaughan for his initial encouragement, and to Andrew Wheatcroft for asking a couple of difficult questions.

PART ONE

The Background

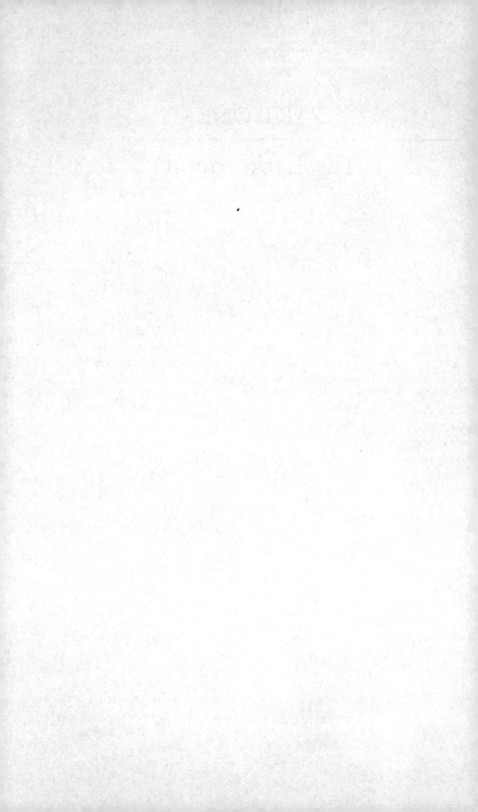

1

The civilising influence of art

Since the end of the Second World War, art has been a political issue. The Labour manifesto for the 1945 election declared that 'we desire to ensure to our people full access to the great heritage of the culture in this nation', a promise that was honoured after the Labour victory with the creation of the Arts Council of Great Britain. Since then it has been assumed, almost without question, that the arts are good for the nation and should be supported.

Quite what 'good for' means has never been fully explored, except in dollar-earning terms. The aim of this book is to show that 'good for' has a history whose hidden assumptions lie behind today's views of what an arts policy should be. Although the area under investigation in this book is fine art – painting and sculpture – its history is similar to the history which has formed contemporary attitudes to the provision of music, literature and dance.

The idea that the arts are good for people has a history which begins in the 1830s and continues today with the Tate Gallery's plans to open a northern branch in Liverpool. The Tate's decision would have been applauded by socially concerned Victorians although they would have presented their reasons in different terms. They would have seen the gallery as an attempt to tame the lower classes through the civilising influence of art, while the moderns see it in terms of correcting the London stranglehold on the arts and revitalising a rundown area. But the use of art to treat a social problem is the same.

It is more than coincidence which links the Victorians to today's developments. Contemporary policies are descendants of nineteenth-century ideas. It was the Victorians who decided that the visual arts were a force for social good. And it was the Victorians who defined the visual arts as painting and sculpture and decreed that they should remain untouched by the crafts or amateur art. These

beliefs that painting and sculpture have an important role to play in society lie beneath the Arts Council's decision to boost galleries outside London, its funding of quality exhibitions and its parsimoniousness towards fine art's embarrassing relatives, community, ethnic and amateur art. The view that fine art is good for people is part of the establishment's mindset, and current niggardliness towards it is a result of adherence to economic policies rather than hostility to something as much above criticism as religion, a receptacle for similar attitudes.

Art has always been thought to possess power. Though the rich and royal, the leaders and the worldly, have always used art to enhance their position, sixteenth-century Italy developed a code of behaviour which included appreciation of the arts as a mark of a noble personality. The everyday descendant of this idea, the belief that sensitivity to the arts is in some way a mark of refinement, lies behind the developments outlined in this book.

The most common British form of the belief in the refining power of art as the nineteenth century approached was the argument that art could lead the mind up to a higher plane. In a speech delivered at the opening of the Royal Academy in Somerset House in 1780, the president, Sir Joshua Reynolds, explained that art could improve society by raising citizens from sensuality to reason:

> It is therefore necessary to the happiness of individuals, and still more necessary to the security of society, that the mind should be elevated to the idea of general beauty, and the contemplation of general truth; by this pursuit the mind is always carried forward in search of something more excellent than it finds, and obtains its proper superiority over the common senses of life, by learning to feel itself capable of higher aims and nobler enjoyments.

Reynolds assumed that it was only the sensibility of the higher classes that could be worked on by art. His conception of the mind's capacity for improvement excluded the poor who were seen as occupying a permanent position at the bottom of the social pyramid: 'when society is divided into different ranks, and some are appointed to labour for the support of others, those whom their superiority sets free from labour, begin to look for intellectual entertainments.'

In the nineteenth century this belief went downmarket and for the first time the poor were included among the potential beneficiaries of the civilising powers of art. The poor and fine art

had not previously kept company but by the 1880s a full-fledged theory had developed about art's power to improve not just the lives of the poor but the poor themselves. In England this idea grew against a background of increasing urban poverty, for which it offered itself as a solution. William Morris's marxist faith in the improvement of working-class lives through the practice of the crafts is the best-known and still fashionable face of this belief. But there were others more famous at the time. When in 1881 Samuel Barnett, vicar of St Jude's, Whitechapel, religious, rich and renowned today as the founder of Toynbee Hall, the world's first settlement house, opened the first of his art exhibitions for the East End poor, he hoped that by looking at pictures the poor would become religious, clean, refined, sensitive, politically conservative and able to pass the doors of public houses without going inside.

For thirty years, Barnett and the small band of reformers he inspired used fine art to being about one or all of these improvements. By employing art to civilise, they were adding an artistic solution to all the other solutions which emerged after 1870 to deal with the problem of the poor.

In the last few years, the desire for the Arts Council to do more to encourage 'popular' arts or to put its money behind community art has been voiced in many books and articles critical of the Council's policies. This criticism perceives two kinds of art: a high art, which includes old masters, contemporary art and everything contained in the phrase 'arts of the heritage'; and popular art, which includes environmental art, community arts, crafts and amateur art. Invoking the name of Saint William Morris, the critics accuse the arts administrators of shoring up an elite and outdated idea of fine art which excludes most of the taxpayers who fund the Council and are supposed to benefit from its activities. The Arts Council replies by claiming to support the best and to make the best available to all, adding with a low thrust that what the critics call art is not really art at all but a cultural form of social work.

This battle is a repeat of one that took place a hundred years earlier. Contemporary conflicts over whether it is better for the public to make or to admire art, whether art is a suitable site for politics or whether it should reserve itself for universal concerns, whether art can be created by amateurs as well as professionals, whether art is exclusively paintings and sculpture or whether it can include trade union banners, advertisements, photography or street art, all have their roots in the nineteenth century. One group says that fine art is painting and sculpture, that it is done by professionals, that it speaks of universal matters and expresses

eternal values and that we should all be educated to appreciate it in order to be considered truly civilised. The opposing group says that art should be widened to include the crafts, that art should be free to criticise society, that amateurs should make art. Each group is a missionary for a different religion. One wants to show the best art to all, the other to involve everyone in an art that is more flexibly defined than the first group would allow. Both positions were in existence one hundred years ago.

Barnett's exhibitions of fine paintings for the Whitechapel unwashed exemplify the first group. Barnett accepted totally that the best paintings were by professionally trained artists. In his view, the role of the audience was to look, to appreciate and to listen to the experts point out the glories and meanings of paintings. Today these attitudes have been taken over by the Arts Council and the like-minded bodies which share its goals of presenting excellence to the public. The William Morris way of seeing and using art typifies group two. Respect for the art of the amateur, the belief that making art is as important for Everyman and Everywoman as looking at it, the view of paintings and sculptures as alien to ordinary people, have been adopted by socialist and community artists.

It is the argument of this book that not only were the battle lines drawn up in the 1880s but the outcome was decided. The way in which community and amateur arts have been pushed back into the wings after their 1970s spell in the limelight echoes the way the fine art establishment cold-shouldered Morris's challenge one hundred years earlier. Morris's ideas had a huge effect on the formation of twentieth-century social policies in the areas of environment and education. His visionary belief that the arts and the quality of life are intimately linked has inspired successive generations. But he made far less impact on the course of fine art in this country than Barnett, whose picture exhibitions have been forgotten.

An account of this lost episode of Victorian cultural history supplies the core of this book. Part I sets out the stages that led to Samuel Barnett's conviction that looking at art would be good for the East End poor. Part II describes his attempt to put this into practice, the ripples it made and its victory over the alternative view of view of how art could be 'good for' people espoused by William Morris. Part III shows how Barnett's practices and ideas are embedded in today's attitudes about art and the public.

The book centres on Barnett because his twenty years of pictures for the poor have never been described, because his influence has

never been charted, and because his spirit hovers today over the Arts Council's fine art panel. Morris, on the other hand, needs no more explanations, except to point out that, contrary to received opinion, of all the fields he influenced, fine art remained untouched.

Education versus elevation

The earliest official formulation of art as a solution to the problem of the poor appeared as an afterthought in a government enquiry of 1836 into 'the best means of extending a knowledge of the arts and of the principles of design among the People (especially the Manufacturing population of the country)'. This Commission was set up in response to fears that declining exports were threatening the country's economic health, and so its main concern was with improving the design skills of British artisans whose lacklustre work was causing their products to lose out to those from France and Germany.

Despite the liberal use of the words 'art' and 'arts' throughout the Commission's Report, it is not painting and sculpture that is meant. The term 'art' referred to something completely different when applied to the artisan from when it was applied to the upper and educated classes. For the rich it meant the fine arts of painting and sculpture; for the poor, the crafts. This difference was never stated, because being understood and accepted – at least by the upper classes who did the defining – it never had to be. It resulted from the class system which operated in the arts. Fine art was what academy-trained artists practised after an extensive and traditional training which involved a progression from drawing from casts, to drawing from life, to painting in oils. Artisans learned a skill or a craft – just how well being one of the concerns of the enquiry – which went into producing the 'manufactures' – the textiles, artefacts and furniture which looked so pallid beside their continental counterparts.

The way the educated changed the meaning of art when they applied it to the poor shows in the one area where the Commission congratulated itself that art had made contact with artisans. The Report can hardly keep its enthusiasm in check for what it

approvingly called 'the paper circulation of knowledge'. 'Cheap publications upon art are studied with interest by our workmen,' it enthused:

> *The Mechanics Magazine* has in this point of view, as well as in its more scientific character, conferred lasting advantages on the manufactures of the country. The immensely-extended publication of specimens of art by means of the steam-printing machine is justly commemorated in the evidence of Mr Cowper.[1]

Edward Cowper was the patentee of the Applegarth and Cowper steam printing machines, an achievement which afforded him much self-congratulation: 'And every Saturday,' he told the Commission, 'I have the satisfaction of reflecting that 360,000 copies of these useful publications are issued to the public, diffusing science and taste and good feeling, without one sentence of an immoral tendency in the whole.'[2]

A glance through these magazines shows what was meant by art for the workmen. Carters Patent Paddle Wheel, two views of Mr Ogle's steam boiler and a small engraving of improved street paving in an 1835 issue show that art as skill, not art as paintings, was meant in calling *The Mechanics Magazine* a 'a cheap publication upon Art'. Another Commission-approved journal, *The Saturday Magazine*, mixed general knowledge with brief entries on what it called the useful arts, like masonry and brick-making. Its illustrations for 15 August 1835, the interior of a Spanish inn, the market cross at Devizes and Wingfield castle in Suffolk, were not what the upper classes would consider art.

This artistic double standard dictated the recommendations of those who reported to the Commission on the kind of art they felt should be put before the artisans. Purpose-built galleries should contain design motifs from Pompeii, specimens of decorative art from the Renaissance, and examples of 'the most approved modern specimens, foreign as well as domestic, which our extensive commerce would readily convey to us from the most distant quarters of the globe'.[3] It sounds ambitious, but what they are actually talking about are designs and objects aimed at improving the design of manufactures. Paintings and sculptures in this context were like icing, nice but not necessary.

The double standard also affected the suggestions on suitable training for artisans. Partly through fear that exposing the artisans to paintings and sculpture would upset the artistic applecart by educating them out of their place and into that of their betters, and

partly through a genuine belief that fine art training would not help them to come up with better designs, the witnesses turned their thumbs down on a training that included too much painting and drawing. Too much high art and 'the unsuccessful aspirants after the higher branches of the arts will be infinitely multiplied and the deficiency of manufacturing artists will not be supplied', feared the architect C. R. Cockerell. Cockerell thought that teaching the artisans such elements of 'the science of art' as proportion, perspective and correct drawing was not 'compatible with the occupations of artisans, and the encouragements to it would mislead them, and interfere with their proper callings, and right division of labour'.

Accepting without question the difference between the two classes of art, he was utterly against giving the artisans any insight into the sacred mysteries of fine art:

> in the latter, the knowledge of artisans, whose bread is earned in laborious work, must be always very limited, compared with those who have an original genius for it, and have been brought up in the highest schools, and with the best opportunity of instruction. This knowledge is a science of itself, and requires a life to attain. There is every respect among artisans towards men of superior knowledge, they bow to them, and follow them implicitly if they have reputation for merit; but I apprehend that any attempt at a general diffusion of the higher principles would be futile.[4]

However, attitudes were not as fixed as they seemed. In the course of the Commission, two ideas slipped in which were to have huge consequences for the nineteenth century's attitude to art and the poor. The first was that exposure to good decorative art might in some way improve the artisans' behaviour as well as their skills. The second was that paintings should be put before the poor, a revolutionary suggestion for an age which believed that it was a useless activity for the poor to look at art without the primary goal of improving design skills.

The arguments for art's power to refine the artisans were sparse and rather nervously put forward. The framework of the Commission damped down the witnesses' imaginations and limited their thinking to the promotion of stability and prosperity. J. Nasmyth wanted factories to exhibit 'a small selection of such of the most graceful forms of antique designs' because 'the absence of such objects to engage their attention is one of the great causes why, after taking their meals at home, the men retire . . . to the

public house.' Self-interest was at the root of this concern, since drunkenness led to

> a system of dissipation which is not only deeply injurious to their own morals, but also to the interests of their employers, returning in an excited state to their work, which evil might not only be removed by the above-mentioned means, but results would be produced not only greatly tending to their own enjoyments, but ultimately to the extension of the national prosperity in regard to improving our manufactures.

The witnesses were frequently helped out by the Commissioners, who were not above putting words into mouths in their wish to believe that exposure to art was good for the poor.

> You throw out these suggestions as really worth the attention of masters who take an enlightened view of their own interests? [Nasmyth was asked.] 'Would you suggest in large towns the encouragement of public exhibitions by the government?' – 'Yes.' 'As improving the minds and morals and even the professional skill of our mechanics?' – 'Certainly.' '... So that if we improved one class, we should find in a short time that the influence had extended in every direction, and thus tend to raise the excellence of the style of the manufactures as well as improve the morals of the workmen.'[5]

Another witness felt that if galleries were opened in Norwich, 'the lower orders of society there would be very much improved in a very short period of time'. 'Do not you think', asked the Committee, 'that the institution of such places of instruction and of such galleries of art would have the effect not only of improving manufactures, but the moral and social conditions of the people?'[6] It would take a brave witness to disagree with such hopeful expectations, and this one did not.

Idea no. 2, that paintings should be shown to the working classes, appeared in the Report, the Commission's summing-up section which carried the Establishment's seal of approval. The comment was made in connection with the twelve-year-old National Gallery, soon to move into its Trafalgar Square premises, and it ran, 'It is far better for the nation to pay a few additional attendants in the rooms, than to close the doors on the laborious classes, to whose recreation and refinement a national collection ought to be principally devoted.'[7] With this statement a completely new idea was introduced into the purpose of art galleries. When combined with the hope that galleries of decorative art for artisans

would increase their social as well as their professional skills, the foundation was laid for art's future role with regard to the poor. In order to enable the poor to benefit from museums either in terms of improving their work or their behaviour, late opening, free entry and clear labelling were recommended.

The 1836 Commission set out two roles for fine art: a major one of education and a minor one of elevation. The use of art to educate manifested itself almost immediately in the setting up of schools of design, by mid-century in the South Kensington Museum, later to be the Victoria and Albert, and by the 1880s in the interest in children's art education, and has been carefully chronicled by education and design historians. The use of art to elevate, on the other hand, is poorly documented and guaranteed to raise a grin. Yet within a few years, ideas of art as beneficial to the intelligence, spirit, manners and behaviour of the lower classes began to exist alongside the purely practical view of its use which was the immediate result of the 1836 Commission.

3

Taking it on trust

In the years following the Commission, the ideas of those who wanted to use art to civilise were timid and confused. Were the fine or the decorative arts to be employed? Was art for education (improving design skills) or elevation (improving morals) or both? Which section of the poor was the target, the artisans, or the lower classes in general?

The opening of the design schools helped clarify matters. Technical education for artisans began with the opening of the first school of design in Somerset House on 1 June 1837 and flowered when twenty-one provincial art schools joined it between 1842 and 1852. Since the object was to produce designers not artists, very little fine art training was incorporated into the syllabus, although debates on the subject continued for years. Once the design schools had assumed the responsibility for educating the artisans, fine art was freed to get on with the job of refining the poor. Right from the start, one thing was accepted by all, and that was that the poor would not get their benefit from art by practising it. The poor's relationship to fine art was envisaged as passive. They were spectators, not creators, for that was the role reserved for the professionally trained fine artist.

The belief that fine art could help the poor quickly became orthodoxy. So few argued against it that a critical cartoon in *Punch* in 1843 (Figure 3.1), entitled 'Substance and Shadow', shocks like a shark in a swimming pool. A crowd of the barefoot, ragged and crippled stands bemused in an art gallery and the text explains that

> There are many silly, dissatisfied people in this country who are continually urging upon ministers the propriety of considering the wants of the pauper population, under the impression that it is as laudable to feed men as to shelter horses.

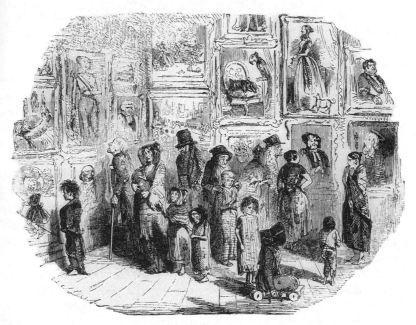

SUBSTANCE AND SHADOW.

Figure 3.1 'Substance and Shadow', *Punch*, vol. 5, 1843.

To meet the views of such unreasonable people, the Government would have to put its hand into the Treasury money-box. We would ask how the Chancellor of the Exchequer can be required to commit such an act of folly, knowing, as we do, that the balance of the budget was triflingly against him and that he has such righteous and paramount claims as the Duke of Cumberland's income, the Duchess of Mecklenburg-Strelitz' pin money, and the builders' little account for the royal stables.

We conceive that ministers have adopted the very best means to silence the unwarrantable outcry. They have considerately determined that as they cannot afford to give hungry nakedness the substance which it converts, at least it shall have the shadow.

The poor asks for bread and the philanthropy of the state accords – an Exhibition.

Punch was presumably not alone in its opposition, but the critics of the belief kept remarkably quiet. At the most basic level, fine art's superiority and the poor's inferiority were such self-evident facts of Victorian life that few could be found to quarrel with the

showing of one to the other. The enlightened thinking of the century favoured the arts as a tool to civilise the new breed of city poor spawned by the Industrial Revolution, and not many went against it.

The Select Committee enquiries of the first half of the century show how completely the belief that looking at pictures was good for the poor was taken on trust. The assertions made by the witnesses on the subject of art and reform were based on precious little evidence. Its followers were true believers, confident that powerful as Orpheus's lute, art could lead the poor away from everything bad and improve their morals, their refinement, their intellect and their environment. Evidence did not come into it.

The belief that looking at art led to the moral and intellectual improvement of the lower classes was written into the terms of enquiry of the 1841 investigation into national monuments and works of art: 'to consider the best means for their protection, and for affording facilities to the Public for their inspection, as a means of moral and intellectual improvement for the people.'[1] Taking it as proved that exposure to art had led to more civilised attitudes among the poor, the Report hoped that inspection of churches would similarly encourage religion:

> as by increased facilities of admission to the inspection of mere works of art, civilisation has been encouraged and public taste improved, so a more free admission to religious edifices, under proper regulation, may be made conducive not merely to the gratification of curiosity and the acquirement of historical knowledge, but to the growth and progress of religious impressions, by leading the mind of the spectator from the contemplation of the building to a consideration of the views with which, and the purposes for which, it was originally erected and is still maintained.[2]

Another commission of 1841 appointed to consider the rebuilding of the Houses of Parliament which had been destroyed by fire years earlier, also takes art's refining role for granted:

> Your committee, are, however, of opinion, independently of the beneficial and elevating influence of the Fine Arts upon a people, that every pecuniary outlay, either for the purposes of forming or extending collections of Works of Art in this country, has been directly instrumental in creating new objects of industry and of enjoyment, and therefore in adding, at the same time, to the wealth of the country.[3]

By the mid-century, the issue of the effect on the poor was always raised when enquiries were made into the arts. In the 1852–3 Commission into the preservation and exhibition of monuments and art, the possible relocation of the National Gallery at the Kensington end of Hyde Park was discussed. The Commissioners worried whether the distance would deter potential visitors from the poor east and southern areas of London and wondered whether Hyde Park's purer air would compensate for the inconvenience of the longer journey:

> 7018 As a matter connected with their health, as well as their amusement and instruction, do you not think it might even be desirable that, when they have a holiday which they intend to devote to seeing these works of art, they should spend that holiday at Kensington, which is on the borders of Hyde Park, which is described as one of the lungs of London, in pure and fresh air, rather than spend it in Trafalgar Square? – I should doubt whether there would be any appreciable difference between the air in the gallery at Kensington and the air in the gallery at Trafalgar-square.
>
> 7019 But in order to reach that gallery, they would have to pass, would they not, through purer air than if they went no farther than Trafalgar-square? – The neighbourhood of Knightsbridge barracks has always been considered especially pestilential.
>
> 7020 Is the air of Hyde Park so? – No.
>
> 7021 Are you aware that the proposed site for the gallery is on the confines of Hyde Park, with an open square behind it? – It is a pretty situation, and an airy one.
>
> 7022 Do you think, generally speaking, that the air there is more healthy, and likely to be beneficial to those visiting the gallery, than that which is to be found in Trafalgar-square? – It may be.[4]

Purer air or not, the secretary to the National Monuments Society wanted the Gallery to stay where it was, agreeing with 'that beautiful opinion expressed by Sir Robert Peel, when the National Gallery was first proposed, that placed in the centre, and in the full stream of London industry, persons of various classes would all meet in mutual good will'. He was worried that the long journey from their homes in the east and south, involving a change at Charing Cross, would so tire them that 'they would also be deprived of the enjoyment they would otherwise have in seeing the

pictures, from the listlessness and feverishness that would ensue after so much exertion'.[5]

Although the claims of art's benefit to the poor came thick and fast, the evidence trickled in more slowly. It was in many ways an impossible point to prove, and the witnesses are not to be envied as they scrape around for examples to back up their assertions. It was one thing to measure the artisans' developing design skills by the improvement in their products or by their success in the examinations introduced by the design schools, quite another to trace the refinement of a working-class mind back to the sight of a piece of art.

The difficulty but necessity of offering proof led to some unconvincing assertions. The 1841 enquiry into the rebuilding of Parliament contented itself with an optimistic reading of increased museum attendances: 'The beneficial influence of Art upon the character of the People, may, it is hoped, be inferred from the gradually increasing numbers of late years who take an interest in our national collections.' But the speaker left it to Reynolds, speaking seventy years earlier to Royal Academy students, to explain how this influence worked: 'It is impossible, in the presence of those great men, to think or to invent in a mean manner; a state of mind is acquired that receives ideas only which relish of grandeur and simplicity.'[6]

Evidence was offered on doubtful grounds and with the most touching hopes. One speaker claimed that the higher the art on offer, the greater the benefits:

> 'As then the collection and exhibition of works of art have not only tended to the moral elevation of the People, but have also given a fresh stimulus and direction to their Industry, so your committee is of opinion that a direct encouragement of the higher branches of Art . . . will have a similar effect in a still higher degree.'[7]

Thomas Wyse MP reported seeing the 'peasants of the mountains of Tyrol holding up their children, and explaining to them the scenes of Bavarian history almost every Sunday' in front of the frescoes in the palace at Munich. Asked whether the King's encouragement of the fine arts had led to a greater appreciation and feeling for art among the people, Wyse replied that judging from 'conversation and the attendance of the public upon places dedicated to the fine arts, especially upon their pictures and sculpture galleries and museums, I should say there is a con- siderably greater love and a greater knowledge of art in Munich at

present, than existed there ten years ago.' It was hardly evidence but it hardly mattered, since everyone wished to believe it. Wyse recommended fresco as a material for inspiring a love of art in the poor since 'It was not to be expected that the lower classes of the community should have any just appreciation of the delicacies and finer characteristics of painting in oil, and that they required large and simple forms, very direct action, and in some instances exaggerated expression.'[8]

The National Gallery supplied examples of art in action nearer home, and the Commissions were full of them. John Peter Wildsmith, a gallery attendant, told the 1841 commission on national monuments that a good number of the working classes visited the gallery 'and they behave extremely well, and some of them take very great interest in the pictures'. He believed interest in the pictures was increasing daily: 'I notice mechanics that come, and they appear to come in order to see the pictures, and not to see the company.'[9]

No one reports a case of resistance to art, let alone a case of bad behaviour in its presence. Since none but the brave or the converted would have dared put a dirty shoe inside the Gallery's doors, this may be a true impression, but it is also possible that having embraced the belief that looking at paintings could magically sober the lower classes, the witnesses were not about to admit any evidence to the contrary. To make art's power appear more dazzling, the working class's potential for bad behaviour was frequently hinted at. Allan Cunningham, author of art books and assistant to Sir Francis Chantrey, informed the Committee that 'you see a great number of poor mechanics there, sitting wondering and marvelling over those fine works, and having no other feeling but that of pleasure and astonishment; they have no intention of destroying them'. These, he told the Committee, were men 'who were usually called "mob"; but they cease to be a mob when they get a taste.' Such tales of good behaviour were so convincing that the Report accepted

> the general disposition of the people to appreciate exhibitions of this nature, and to avail themselves of these means of instruction and innocent recreation. It affords, further, the most satisfactory evidence of the safety with which works of art and other objects of curiosity may be thrown open to public inspection.[10]

The hope of the 1836 Commission that exhibitions of decorative art would wean the artisans off their lunch-hour drinking metamorphosised into a fact within a very few years, and within a

few years after that into a policy of combating all working-class evils with art. Supporters of Sunday museum opening, that debate which lasted almost as long as Victoria's reign, argued that a member of the working classes in a museum on Sunday was a member of the working classes not in a public house. Opponents argued that a member of the working classes in a museum on Sunday was a member of the working classes not in church. Sir Henry Ellis, the British Museum's principal librarian, told the 1841 Commission that he felt a museum's contents changed from educational to entertaining on a Sunday. When asked whether it was not better for people to go into a museum than into a public house, he replied that he did not think 'that the Museum would be an attraction to any party who might be inclined to go into a public-house on the Sunday'. 'You consider the Museum a mere show, without affording any instruction to the visitors?' the Commission enquired with a glint in its eye. 'On the Sunday it would be a mere show,' he replied. When asked whether he was aware that the public houses were fuller on Sunday afternoons than on other days of the week, he replied that he could not answer that question 'for I go very little about London on the Sunday'.[11]

But most witnesses felt that 'much moral instruction might be gained by visiting the Museum of Natural History and Fine Arts instead of people being confined at home in close rooms or frequenting public houses and similar places'.[12] A witness to the 1852–3 Commission thought that church attendance would encourage the poor to conduct themselves better on Sunday than any other day, 'besides which, they would be nicely dressed, and the fear of dirt would be less'. Asked whether he would 'allow the admission of the public on a Sunday on the grounds that rational, innocent, and instructive amusements are extremely desirable for the great mass of the community on that day', he replied in the affirmative: 'the old verse in the Latin Grammar naturally occurs to me, *emollit mores nec sinit esse feros*; the tendency of fine art cultivation must be to humanize and civilise.'[13]

Although firmly held, the belief in art's power to refine the poor in the years around mid-century was more a matter of faith than evidence. Taking its lead from the 1836 Commission, most thinking on art and the poor focused on the improving of artisans' design skills, a matter seen more in terms of education than elevation. The fact that elevation, puny offshoot though it was, survived and bloomed, owed much to the development of theories which brought fine art into increasingly close contact with the lower classes.

4

A kindly context

Although on the surface one of the century's odder attempts at reform, pictures for the poor grew naturally out of nineteenth-century concerns and developments.

The problem of the poor in the nineteenth century was like a chronic illness which occasionally became acute. Disraeli's *Sybil*, in which he described England's two nations of rich and poor, was an influential expression of the unease it aroused in the 1830s, and Mrs Gaskell's *Mary Barton* showed how the problem was perceived a decade later, with Manchester the symbol of the social horrors industrialisation had brought to the north. By 1870 the problem had reached London. The words East End acquired the horrified overtones formerly associated with Manchester, and the powerful who lived in the capital could no longer pretend that the problem had nothing to do with them.

The problem had many faces in the century's last three decades. But put at its simplest, it was obvious to all but the rose-spectacled that there were a great many poor people and that they worked and lived in conditions which would be unacceptable to the savage tribes with whom they were so often compared. In 1883, George R. Sims explained the purpose of his book *How The Poor Live*:

In these pages I propose to record the result of a journey into a region which lies at our own doors – into a dark continent that is within easy walking distance of the General Post Office. This continent will, I hope, be found as interesting as any of those newly-explored lands which engage the attention of the Royal Geographical Society and the wild races who inhabit it will, I trust, gain public sympathy as easily as those savage tribes for whose benefit the Missionary societies never cease to appeal for funds.

Sims's journey to the East End was not the first investigation into the life of the poor to appear in these decades. There were so many written and illustrated descriptions of the lower classes that it was impossible to remain in ignorance of their condition. Documentary accounts of poverty in the genre begun by James Greenwood with *A Night In The Workhouse* of 1866, periodically disturbed the readers of the *Pall Mall Gazette*. Sims's *How The Poor Live* was followed by his *Horrible London* (1889), Mearns's *The Bitter Cry of Outcast London* (1883) and William Booth's *In Darkest England* (1889). Fiction produced George Gissing's slum novels of the 1880s while in 1894 came the most notorious use of slum subject matter, Arthur Morrison's short stories, *Tales of Mean Streets*. The illustrated weekly *The Graphic* was founded in 1869 with the spotlighting of social evils as one of its aims, a path it stuck to for almost a decade. Even art lovers could not escape. Visitors to the Royal Academy summer exhibition found themselves face to face with large-scale pictures of the urban poor which were far more disturbing than the picturesque poverty of rural folk or foreign peasants they were used to. There were only a handful of paintings in this social realist style, but the shock they caused was out of all proportion to their numbers. The ragged characters queueing for tickets for a night in the workhouse in Luke Fildes's *Applicants For Admission to A Casual Ward* (Figure 4.1) created a huge stir at the 1874 summer show, and was, some thought, too shocking a subject to be allowed into art. Though few matched Fildes's bleak vision, in the 1880s and 1890s several artists produced documentary scenes involving the poor. Hubert Herkomer painted immigrants landing in New York in *Pressing To The West* (RA 1884), families waiting for news of a shipping disaster, and a heroic striker with his wife and child (Figure 4.2). Dudley Hardy pictured the London dock strike in 1889 and the homeless in Trafalgar Square (*Sans Asile*, 1889). These reports and visualisations were complemented in the 1880s by efforts to collect a statistically accurate picture of the lower classes. The government set up a number of enquiries, and in 1889 came *East London*, the first volume of Charles Booth's survey, *Life and Labour of the People In London*.

A result of all this exposure was that the problem of the poor was thrust in front of people, a topic for discussion at dinner parties as well as at Downing Street. A cartoon in *Punch* for 22 December 1883, 'The Very Latest Craze or Overdoing It' (Figure 4.3) depicts a group leaving a party:

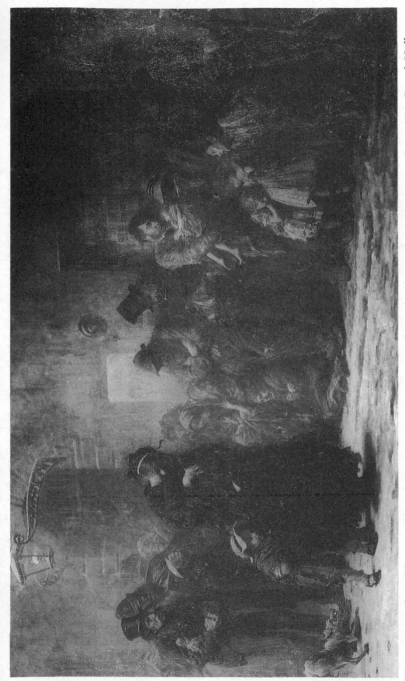

Figure 4.1 Luke Fildes, *Applicants for Admission to A Casual Ward*, oil, 142.2 × 242.6 cms, RA 1874, Royal Holloway and Bedford New College collection

Figure 4.2 Hubert Herkomer, *On Strike*, oil, 224 × 124 cms, RA 1891, Royal Academy of Arts

'What, going already? And in Mackintoshes? Surely you are not going to walk!'

'Oh dear no! Lord Archibald is going to take us to a dear little slum he's found out near the Minories – such a fearful place! Fourteen poor things sleeping in one bed, and no window! – and the Mackintoshes are to keep out infection you know, and hide one's diamonds, and all that!'

Problems do not automatically receive help. This one did because the realization that the poor actually did have something to be aggrieved about was accompanied by a fear that they might take matters into their own hands. It seemed all too possible that a poor made desperate by unemployment and envy of the upper classes would resort to the violence that was seen as an almost automatic outcome of life in the slums. As terrifying as the spectre of violence was the spread of the new socialist and anarchist ideas – the two were not always separated in people's minds at this period. The vote was extended to working-class men in 1867, and the chance that they might elect members of parliament with radical ideas was only marginally less worrying than the fear that they would try and get a better deal for themselves by force. Vulnerable and frightened, those with most to lose had to do something to save themselves from those with nothing to lose.

Inspired by self-interest or sympathy or both, the solutions came from all sides, from individuals, from societies, from the government. Assorted reformers turned their attention to all areas of life of the poor, leaving nothing untouched from their souls to their sanitation. Showing pictures to the poor was only one solution among the many put forward at this period to solve the problem of the poor.

There was a long way to travel between a general agreement at mid-century that it was good to show paintings to the poor and Barnett's exhibitions at the century's end. A kindly environment that nurtured the belief's survival and growth was supplied by the spine of Victorian thinkers who, despairing over the social problems created by the Industrial Revolution, looked to the arts – architecture, the crafts, or just culture in general – to improve the quality of life. Utopians have only two ways to look, and it is a mark of these particular cultural problem-solvers that they all looked backwards. Because the Industrial Revolution had led to a flood of ugly machine-made goods, the thinkers looked back to the age of crafts. Because it had tied workers to machines, the thinkers looked back to a time when goods were made by hand. Because it

THE VERY LATEST CRAZE; OR, OVERDOING IT.

"What! going already! And in Mackintoshes! Surely you are not going to Walk!"
"Oh, dear no! Lord Archibald is going to take us to a dear little Slum he's found out near the Minories—such a fearful place! Fourteen poor Things sleeping in One Bed, and no Window!—and the Mackintoshes are to keep out Infection, you know, and hide one's Diamonds, and all that!"

Figure 4.3 'The Very Latest Craze; or, Overdoing It', *Punch*, 22 December 1883

had drawn the poor to the cities, the thinkers looked back to a rural society. The age preceding the Industrial Revolution became a golden one.

An early formulation of the theory linking the arts, medieval times and a good society came in 1836 when Augustus Welby Pugin advanced the thesis in *Contrasts* that a great religion, Roman Catholicism, had given rise to a great architecture, Gothic, and to a great social system, feudalism. He supported his claim for the superior state of English society in the Roman Catholic centuries by comparing buildings from before and after the Reformation and drawing a conclusion about their respective societies from this. For example, the Gothic West Cheap Conduit built in 1479 allowed access to the water to all citizens whereas the well at St Anne's Soho, built in classical style, was kept locked. By an illogical though imaginative extension of this idea, Pugin suggested that if modern states were to build in a Gothic style, the virtues of the earlier Catholic age would return.

His message that medieval society held the solution to contemporary social problems made sense to thinkers despairing over the mess society was in, and fifteen years later John Ruskin restated

Pugin's belief that medieval society and good art were bound together. Not being a Roman Catholic, he felt obliged to free Gothic architecture from its unacceptable Catholic connection, a feat achieved by replacing Pugin's theory with the claim that the asymmetrical Gothic had grown out of an affinity with the mountainous northern landscape and was therefore the natural building style of the north. In 1853, Ruskin's *Stones of Venice* was favourably reviewed in *The Times* and the volume's most famous chapter, 'The Nature of Gothic', began its career of shaping its readers' attitudes to modern industry. Drawing a picture of the fulfilled artisan chipping and carving to create the Gothic cathedrals, Ruskin proclaimed that Gothic architecture was great because it reflected its builders, a superior brand of free men far removed from their nineteenth-century counterparts whose nature was broken by working at machines 'into small fragments, crumbs of life'.[1]

At the end of the 1860s, the linking of art to life was taken further with Matthew Arnold's *Culture and Anarchy*, in which appreciating replaced practising and culture replaced crafts. Arnold gave culture the power to assure the country's stability, a stability which seemed threatened by the extension of the vote in 1867: 'Through culture seems to lie our way not only to perfection but even to safety,' he wrote. And he claimed that 'we nevertheless may do more perhaps, we poor disparaged followers of culture, to make the actual present, and the frame of society in which we live, solid and seaworthy, than all which our bustling politicians can do.'[2]

William Morris, who was the last in this line of cultural reformers, did not perfect his theories until the late 1880s, when the pictures for the poor movement had already found its feet.

By far the most important influence on the cultural reformers was Ruskin. No matter that he had not had a new idea since the 1860s and that his mental breakdowns began in the 1870s. No matter that in the 1870s he had begun to despair of anything improving the lot of the urban poor, who were the target of the pictures for the poor reformers. Setbacks that would have written off a lesser man had no effect on his elevation to Victorian sage which began in the 1870s. The bagginess of his writings meant that he could be all things to all people – both Barnett and Morris, cultural reformers who would end up on different sides of the cultural fence, would cite chapter and verse of Ruskin in support of their actions to improve the life of the Victorian poor.

Ruskin's linking of art, society and Christianity in a complete

and convincing artistic philosophy was a gift to the Anglican reformers of the 1880s and 1890s who found themselves in church or settlement house surrounded by the poor in desperate need of improvement. They probably had not read his every word, but his ideas invaded Victorian minds between 1855 and 1900, and were particularly congenial to the cultural reformers who scattered quotations from his works all over the catalogues they produced for their art exhibitions.

Of practical use to reformers showing pictures to civilise and elevate the poor was Ruskin's nineteenth-century version of the age-old idea that a divinity belonged to painters and their productions. The greatest class of painters, he wrote, 'render all that they see in nature unhesitatingly, with a kind of divine grasp and government of the whole, sympathising with all the good, and yet confessing, permitting, and bringing good out of evil also.'[3] Just as useful to reformers who wanted to use pictures as parables was the Ruskinian equation between a painting's greatness and the number of ideas it contained. Ruskin also gave the reformers the authority to use fine art as a sometimes substitute, sometimes synonym, sometimes parable for religion: 'Art is not religion, nor can it produce religion; and yet there is such a close connection between religion and the highest art, that the former seeks to express itself through the latter,' wrote the Rev. J. Scott Lidgett, Warden of Bermondsey Settlement which copied Barnett's exhibitions in the 1890s.[4] Far from introducing esoteric aesthetic concepts, Ruskin used religion as a critical tool:

> So that true criticism of art never can consist in the mere
> application of rules; it can be just only when it is founded on
> quick sympathy with the innumerable instincts and changeful
> efforts of human nature, chastened and guided by unchanging
> love of all things that God has created to be beautiful, and
> pronounced to be good.[5]

Even without 'amen' it sounds like a prayer.

Equally appealing to reformers dedicated to bringing the lower and upper classes into sympathy with each other was the Ruskinian interpretation of contemporary society. His vision of the class antagonism fostered by capitalism was as bleak as that of Karl Marx. He recognised the profit and loss basis that underlay capitalism's most impressive pronouncements. He said that making yourself rich is the art of making others poor. He believed that capitalism diminished the worker, talking of men producing bits of things in his version of Marx's division of labour. But while his

analysis was radical, his solutions were not. Where radicals proposed a redistribution of wealth, Ruskin proposed that the rich should use their wealth with a bit more social conscience. Where the radicals thought of ways to abolish the boss-worker relationship, Ruskin thought in terms of improving it, suggesting in *Unto This Last* in 1862 that workers could be motivated by respect for their employers and *esprit de corps* among themselves and that political economy was wrong to regard them as covetous machines. Built on the piercing and pessimistic analysis was a positive dream of society as an organism of interdependent parts. While radicals believed that only a revolution could bring about better conditions, Ruskin hoped that a change in attitude on the part of rich and poor would do the trick.

At the same time as the theories linking art and the poor were finding their feet, fine art began to occupy an increasingly important place in Victorian life. A proof that art 'mattered' comes from a leader in *The Times* of 1 November 1878, which was inspired by a section devoted to art at a recent Social Science Congress in Cheltenham:

> This Art Section at Cheltenham simply demonstrates the fact that wide-spread attention is now paid towards art. Men, and women also, devote themselves to it. They talk about it incessantly. They read it up. It has become a cult; and long and painful are the pilgrimages paid by its votaries to the altars recommended by their several confessors and directors. It abounds in sects which excommunicate one another in orthodox fashion, and the State has been induced to take up the new faith, to build a central temple for its accommodation at South Kensington with a large staff of ministrants, and to establish subsidiary oratories throughout the land, each with its proper teacher or staff of teachers. . . .

The leader continues:

> Take up any magazine, review or weekly journal, and rival authorities will be discovered. Mr Ruskin pronounces in an infallible manner in one sheet; Mr Sidney Colvin in another, or perhaps, in others.

The final factor in readying art to tackle the problem of the poor was the growing dissatisfaction with traditional philanthropy. Like a blanket of snow, the twentieth century view of philanthropy as the giving of money to the poor has obscured the variations which lie beneath. In particular, it hides the fact that discussion over how

best to help the poor had by the 1880s become heated and partisan. Mary Booth wrote that her husband Charles started work on his seventeen-volume *Life and Labour of the People of London* because of the contradictory remedies advanced for treating the problem of the poor, and because he believed that assumptions made about the problem were unconnected with the facts. There was a general lack of confidence in the target – was it improvidence, self-indulgence or the bad environment of the poor classes, or was it the bad behaviour of the higher, example-setting classes? – and in methods of attack: 'The simple, warm-hearted, and thoughtless benevolence of former ages was held up to reprobation. Those who desired to help the poor were exhorted not to give money, still less food and raiment, but to give themselves, their time and brains,' she wrote in her memoir of her husband.[6]

By far the strongest strand in this faltering confidence in simple philanthropy was the belief – or fact as it was considered – that giving the poor money only succeeded in demoralising them. Pauperisation was the contemporary term for the view that felt that charity sapped the poor's will to work by encouraging them to stand with outstretched upturned palms. The money and goods intended to improve their standard of living turned them into permanent parasites on charity, while their moral standards stayed distressingly low. Much effort went into finding solutions to the problem outside the philanthropic framework, which was felt merely to relieve the conscience of the rich while perpetuating the squalor and low thinking of the poor.

The pictures for the poor movement was one of the ways out of the dead end of traditional philanthropy. Since it was obvious that money thrown into the pit of deprivation had neither filled it in nor improved its recipients, the reformers were motivated by a decision to approach the problem from another angle. What would happen, they wondered, if we were to concentrate on improving the poor's characters instead of their material surroundings. Because pictures replaced money and were shared not given, they could not pauperise the poor, and because the object of the exercise was to refine the minds of the lower classes in order to make them more responsible in their attitudes, the reformers could rest assured that whatever it was they were offering, it was certainly not philanthropy.

Cultural philanthropy could only come about when all these factors coincided. Ruskin's theory of a cultural solution for society's ills achieved the status of a received idea; the problem of the poor became an eyesore; confidence in traditional philanthropy waned. All that was needed was the people to put the idea into

operation, and these were to hand, as well. In the nineteenth century, the concept of gentleman was expanded from artistocrat to someone with the right kind of liberal education, and this new gentry relied more on its education and its specialised professional knowledge as a claim to respectability than on the family tree and fortune it did not always possess. This was the class the cultural philanthropists belonged to. They imparted culture not money to the poor and set up settlement houses, palaces of art and museums as the counterparts for stately homes from which to dispense such knowledge.

The theory of cultural philanthropy

Reform through culture was based on a view of the poor as an alien breed. The reformers saw nothing good in the poor's way of life, which appeared to them as a series of lacks – of refinement, of imagination, of education – of everything which the reformers congratulated themselves on possessing. Like Professor Higgins wanting women to be more like men, the cultural reformers yearned for the poor to be more like themselves. The goal was ambitious – nothing less than the production of a new-style working class viewing the world with the eyes of the rich and sharing the values and ideas of the classes above them. Culture was to be the means of achieving this dream of a united society in which rich and poor stood side by side instead of eyeing each other with hostility. As Barnett said, 'there can be no real unity so long as people in different parts of a city are prevented from admiring the same things, from taking the same pride in their fathers' great deeds, and from sharing the glory of possessing the same great literature.'[1]

The particular target of cultural philanthropy was the urban working classes. The problem which art was marshalled to fight was the squalor of the cities and the squalid habits of those who lived in them. It seemed an insurmountable problem at the time, one commentator claiming that it either led thinkers into the camp of social revolution or, like Ruskin, to the country. The cultural philanthropists neither ran away nor preached revolution. They believed that art could play a role in combating the grim city environment, which they felt led to immorality, drunkenness, a limited view of life's opportunities and political radicalism, all the bad elements which they considered endemic to the life of the urban poor. All shared a basic belief that bad environments led to bad people and that bad people led to bad environments. Art had

the power to break this circle. Reformed by art, the people would improve their way of life, and once reformed there would be no chance of their ever again being gripped by vicious habits or dragged down by hopeless surroundings.

Samuel Barnett is a textbook example of a reformer who travelled the route from traditional to cultural philanthropy. In his first parish in Marylebone in the 1860s he had helped Octavia Hill form the Charity Organisation Society, that famous Victorian attempt to organise the reception and distribution of the various monies sent to the poor by individuals and institutions. This experience convinced him that though money could temporarily alleviate distress, it could not be relied on to make a permanent improvement. The only way to do that was to improve the characters and way of life of the poor through the personal example of the upper classes, whose fine behaviour, morality, education and refinement would succeed in smoothing the roughness from their inferiors. As he gained experience in the Whitechapel parish he took over in 1873, he transformed this conviction into action. The crude behaviour of the East End poor, combined with his spiritual cast of mind, decided him on his path of refining the poor through culture. Although Barnett's fame today rests on his reputation as a social reformer, his wife pointed out that it was his desire to teach the people religious truths which lay behind his social works: 'It was because they were living under circumstances which precluded them from receiving such truths, that he poured his whole life's force into improving conditions.'[2]

The event that was to turn this austere clergyman into the conveyor of fine art to the Whitechapel poor was his discovery that 95 per cent of East Enders never entered a church. 'Few of the East End places of worship have a congregation, and we may as well face the fact that our forms of service have ceased to express the religious wants of the people.' Far from blaming the poor, he blamed the church: 'the feelings exist but they find neither support nor expression in the means of worship which have been provided.'[3]

It was to tap these feelings that Barnett began his cultural programme. Realist enough to understand that the church had no charms for his parishioners, yet committed to spreading the religious values of love, duty and self-denial, he chose fine art exhibitions, along, it must be said, with everything else he did, to spread his Christian message.

His hope was that by teaching the poor to admire the beautiful, they would better understand the preacher. Art in the service of

Christ was what the Whitechapel exhibitions were all about. His particular piece of originality, pressing pictures into the service of religion, was a result of his belief that fine art encapsulated moral truths.

Because he thought that artists made the beauties of life and nature permanent, he saw pictures as a medium between God and the people and endowed them with a quasi-holy status. Though not the sort of Christian to be comfortable in crediting artists with divine powers, he had the exaggerated Victorian respect for pictures and painters. Paintings, he said, were as valid a form of worship as church to others differently educated;[4] they were messages from the unseen world;[5] pictures and pianos were not a substitute for religion, but were valuable in training the imagination.[6] Through the increased spirituality brought about by looking at pictures, the poor would grow disgusted with their Whitechapel way of life and receptive to religion.

The replacement of traditional philanthropy with its cultural descendant was common in the 1880s, and while Barnett was pressing pictures into the service of religion, his friend T. C. Horsfall, founder of the Manchester Art Museum, was pressing them into the service of nature. Nature was Horsfall's answer to social problems because he believed that sensitivity to beauty was the key to a better life, and this sensitivity came from seeing beautiful natural objects in childhood. Since the urban poor were denied this opportunity, pictures could be the medium through which they came into contact with flowers, birds and landscapes. For one of art's chief functions, 'though art critics fail to tell us so, is to reveal the beauty of things to those who but for art would not see it.'[7]

In *The Relation of Art to the Welfare of the Inhabitants of English Towns* (which boasts a quirky preface by Ruskin begging Horsfall not to waste his 'artistic benevolence' on Manchester), he faced up to the criticism that money spent on art was wasted compared to money spent on social reform: 'To many persons the payment of a high salary to a Director of Art Galleries by the Manchester City Council would seem as silly an act as the giving of a smart bonnet to a woman dying from want of food.'[8] His answer was that by teaching the poor to discriminate between beauty and ugliness, their lives would become less sordid. Without the sense of beauty given by nature, all social reforms were doomed to failure:

> Look at the subject of public-house reform. No one can believe that in the crowded parts of Manchester the closing of all public

houses would be followed by an improvement of life: the tastes and habits, which are partly the result, but in great measure also the cause, of the present state of public houses, would still continue, and find expression in places very like public-houses.[9]

With the help of pictures of the natural world, the working classes could be taught to view life as highly interesting without recourse to public house or music hall. Eyeing society's 'most conspicuously healthy' members, he concluded that their knowledge of nature meant that their leisure was filled with interesting and wholesome activities: 'if they are in the country, what any walk shows them gives them pleasure; if they are near a museum or picture gallery they can find pleasant occupation there for many hours at a time.'[10] Without a knowledge of nature, books and newspapers must remain incomprehensible. What power can the Bible hold, he asked, for a reader who cannot summon a mental picture of such phrases as lily of the field?

Educated by art into an appreciation of nature, the shortcomings of the poor would disappear, from their habit on day trips to staying too close to the main roads to their drunkenness, which he hoped to tackle 'scientifically' by teaching a dozen children a year the names of flowers and animals, the location of local beauty spots, a knowledge of the forces which shaped the earth, and an explanation of artistic techniques.

In 1882, while Barnett was exhibiting art to spiritualise the East Enders and Horsfall was arguing for childhood exposure to pictures of nature as a counterweight to adult acceptance of such blights as drink and dirt, Walter Besant published a novel which suggested that art could close the gap between the classes, improve social conditions and draw the poor from radical politics.

All Sorts and Conditions of Men is the story of an heiress who goes to the East End not to deliver tracts or teach but to get the poor to join her in pleasure and amusement in a Palace of Arts: 'She was going, in short, to say to them: "Life is full, crammed full, overflowing with all kinds of delights. It is a mistake to suppose that only rich people can enjoy these things."'[11]

Besant's stress on the joy brought by art contrasts with the solemnity of Horsfall and Barnett's approach. At the end of the decade, Barnett became a trustee of the People's Palace in the East End, which had been inspired by Besant's novel, and a comparison of his and Besant's reactions underlines the difference in their attitudes. Besant regretted that within a few years of its opening a 'polytechnic was tacked on to it: the original idea of a place of

recreation was mixed up with a place of education',[12] whereas Barnett wrote of the early days that 'inwardly one is haunted by the fear that it all means play and not work and leaves one to ask the question "what is the end?" '.[13]

The end, as always – at least as it was expressed in Besant's novel – was the attempt to make the poor more like the rich. 'I wish they had more knowledge of books, and could be got to think in some elemental fashion about Art. I wish they had a better sense of beauty, and I wish they could be persuaded to cultivate some of the graces of life,'[14] laments the hero. Art to Besant was a portmanteau word for the amusements which made upper-class existence pleasant and which, if practised by East Enders, could bring a bit of joy into their monotonous lives. The novel envisions East Enders throwing themselves into dancing, singing, sports, gardening, cookery and all the arts and crafts, till there is no East End house without 'its panels painted by one member of the family, its woodwork carved by another, its furniture designed by a third, its windows planted with flowers by another'.[15] Despite the arts and crafts overtones, the influence is Ruskin, not Morris. Besant was as conservative as the other two in his desire for a middle-class worker, and like them he dreamed of a society in which rich and poor were interdependent: 'Society is like the human body, in which all the limbs belong to each other . . . if the rich do not work with and for the poor, retribution falls upon them. The poor must work for the rich, or they will starve.'[16]

A distinguishing mark of the cultural reformers was their insistence that they were not offering philanthropy. All of them tried to hide the fact that art had anything to do with money.

Barnett was genuinely convinced that culture, not money, was what was needed to cure the East End's problems, and he was much more distressed by the poor's lack of culture than by their lack of cash.

> Too often has the East End been described as if its inhabitants were pressed down by poverty, and every spiritual effort for its reformation has been supported by means which aim only at reducing suffering. In my eyes, the pain which belongs to the winter cold is not so terrible as the drunkenness with which the summer heat seems to fill our streets, and the want of clothes does not so loudly call for remedy as the want of interest and culture.[17]

It takes a lot of confidence to be convinced that culture, not cash, was the solution to some of London's most lawless behaviour and

worst poverty. The reasons why he was less distressed by poverty than by the poor's vulgarity can only be guessed at. His writings show that he understood that financial inequality was the root of social inequality; most likely he felt that nothing could be done to alter what he considered to be the permanent condition of society. Although money was what separated the rich from the poor, he never once considered closing the gap by making the poor richer. Instead he sidestepped the whole sticky area by analysing it in terms of culture, not money, and giving it a solution he could handle. The moneyed classes had the cultural advantage, therefore the moneyed classes must ensure the poor had them too. In a contribution to a booklet aimed at getting gallery visits recognised by the Department of Education, he revealed with crystal clarity his strategy of closing the class gap by culture, not money: 'It is impossible to make the poor rich, but it is possible by "rationalising luxury" to make more common the best part of wealth.'[18] It was not so much doublethink as wishfulthink. He saw money as the source of the problem, but refused it a place in his programme of reform.

The Barnetts could never bring themselves to talk about money to the poor. In their educational work with the exhibitions, they tried to cut art loose from any financial taint, ending the practice of voting for favourite pictures when they realised visitors thought they were taking part in a lottery for valuable paintings. Though their distress at the connection of money with art sprang from genuine conviction that pictures were pearls beyond price, it must also have had a more complex side. Perhaps they were fearful that any hint of the value of the pictures would aggravate the visitors' discontent and encourage the less spiritual side of their natures, two tendencies the exhibitions were intended to combat.

Besant, too, in *All Sorts and Conditions of Men*, insisted that his cultural answer to drab East End lives was nothing to do with philanthropy. Believing that the problem demanded a more imaginative action than the pouring of money into the normal channels of charity, Besant announced his manifesto as 'the necessity of pleasure, the desirableness of pleasure, the beauty of pleasure'.[19] Money invested in the Palace of Delight is not philanthropy, he explains, because it uplifts the poor, and an uplifted poor means that the Palace escapes philanthropy's faults of perpetuating bad social conditions and encouraging pauperism. It is also not philanthropy because the gift has changed from money to joy, and it is impossible to put a financial value on joy. The muting of the fact that money is the basis of the gift of joy

enables Besant to present the Palace of Delight as a sharing of the
'free' delights of culture.

> It is a mistake to suppose that only rich people can enjoy these
> things. They may buy them, but everybody may create them;
> they cost nothing. . . . All these things which make the life of rich
> people happy shall be yours; and they *shall cost you nothing.*
> What the heart of man can desire shall be yours: *and for
> nothing.* I will give you a house to shelter you, and rooms in
> which to play; you have only to find the rest. Enter in my
> friends; forget the squalid past; here are great halls and lovely
> corridors – they are yours. Fill them with sweet echoes of
> dropping music; let the walls be covered with your works of art;
> let the girls laugh and the boys be happy within these walls. I
> give you the shell, the empty carcase; fill it with the Spirit of
> Content and Happiness.[20]

The 'let them eat cake' overtones of this attempt to use art to
refine the East Enders is typical of cultural philanthropy, an
inevitable result of the reformers' refusal to allow money a role in
producing an improved working class. But though an imaginative
move to substitute culture for money, the reformers were still in the
business of philanthropy. The giving of rich to poor might have
been translated into an aesthetic, money-free context and the goal
transformed from material to spiritual improvement, but the idea
of the privileged giving to the underprivileged was retained.

It could never be claimed that taking pictures to the poor was a
major movement. It takes a telescope to find it among the
thousands of schemes to improve the lot of the poor in late
Victorian England. Yet for all its quirkiness, it sits comfortably
among the ideas of its age, not just the ideas about art and society
but among broader ones about philanthropy's role in improving
the life of the poor. Far from a hopeful fantasy entertained by
cultural philanthropists, the goal of the individual's character
improvement was basic to many of the more practical schemes to
ameliorate the living conditions of the late-nineteenth-century
poor. That material improvements were destined to failure without
a corresponding improvement of character on the recipient's part
was accepted by all the advanced social reformers at the century's
end. The housing reformer Octavia Hill echoed Horsfall when she
wrote that 'The people's homes are bad, partly because they are
badly built and arranged; they are tenfold worse because their
habits and lives are what they are. Transplant them tomorrow to

healthy and commodious homes and they would pollute and destroy them.'[21]

The movements also shared a belief that the personal example and involvement of the upper and educated classes was the way to improve the poor. There was no difference in approach between Octavia Hill's upper-class rent collectors gently but insistently instilling a sense of responsibility into the buildings' tenants and Barnett preaching the higher life to his exhibition visitors. A new improved working class was the goal they all shared, a goal given equal weight to improved conditions.

6

Pictures for the poor

Like the theory of cultural philanthropy, the act of putting pictures before the poor moved like a snail until about 1870. An early attempt was made in 1846 when the *People's Journal*, a publication aimed at the artisan, printed reproductions of paintings. The editors were attacked for this unprecedented move and bravely rose to defend themselves:

> And now let us say a word or two in answer to hints which we have received that in presenting these masterpieces of art we have adopted too high a standard of excellence for a portion of our readers – the working classes . . . to elevate the masses is our great aim; this can never be done by either writing down 'to the meanest capacity' as the practice has hitherto been of popular literature and art. To familiarize the eye to what is beautiful is to educate it. In doing this we are labouring in a worthy cause, for this knowledge of the Beautiful is the one great point in which our working classes are inferior to those of Continental nations.[1]

The reference reveals the *Journal*'s inspiration as the 1836 Commission, a debt underlined by the masthead which announced that it was 'combining amusement, general literature and instruction with an earnest and businesslike enquiry into the best means of satisfying the claims of industry'. The journal exactly mirrored the Commission's ambivalence, in that it felt confident about improving the artisan's taste but less certain when using fine art to do the job:

> Go forth, then, little prints! Take the place upon the walls of the artisans' dwellings of the coarse daubs which appeal only to the worst passions – pictures of prize fighters, of Battles, of Jack Shepherd and Dick Turpin, made heroes by those who should

have elevated instead of degraded your taste. Let the spinners put them up against the beams of their looms – such pictures as these are lessons which a man cannot have too constantly before him. . . . How grand is the experiment we are making! Disregarding the suppressed sneers of the mere dilettante we say boldly to the working man, we trust you, we believe in you; art is for you as well as for the select circle.[2]

Artisans got to see a little bit of fine art through the circulating collection of the Department of Practical Art, which in 1854 began sending objects to the provincial design schools, partly to show students examples of good design, partly to encourage the formation of local museums. The exhibitions were free to the students but made a charge to outsiders, lowered after 1860 to one penny on three evenings a week to encourage visits by those in full-time employment. Within a few years, the Department extended its exhibition circuit to take in the local industrial exhibitions which followed in the wake of the 1851 Great Exhibition. At first, objects alone made up the Department's circulating collection, but after 1860 pictures were added. It was nothing dramatic, but a Minute of 29 March 1860 announced that 'in consequence of the liberal gift of Mr Sheepshanks, it will also be possible to add pictures and engravings to the classes of objects to be circulated'. Among the glass, lace, metal, pottery and fabrics, the artisans could look at watercolours, prints, engravings and photographs of old master drawings. Paintings also crept into the circulating collection from other sources. In 1854, Queen Victoria allowed some of her Sèvres porcelain to be sent to design schools, and this set a fashion for provincial collectors to augment the Department's collection when it reached their area. Although most people loaned objects, an increasing number sent paintings as the years passed. From 1859 to 1875 the Bath and West of England Society arranged for the circulating collection to be supplemented with paintings loaned by local benefactors at its annual show: 'And by this means the Society has been instrumental in bringing examples of fine and industrial art before the visitors to its agricultural shows, many of them dwellers in remote country places not perhaps to be reached in any other way.'[3]

The 1836 Commission's simple and sensible recommendations of extended opening hours, free entry and clear labelling took years to be implemented. With the exception of the South Kensington Museum, founded as a museum of decorative art with the interests of the artisan at heart, and its little sister the Bethnal Green

Museum, both of which were free and stayed open until 10 p.m. several nights week, London's major art outlets dragged their feet when it came to accommodating the needs of those who worked all day. A Royal Commission of 1851 suggested that the Royal Academy open its summer exhibition in the evenings, but it was ten years before the Academy decided to open 'on certain evenings during the season for the admission of the working classes'. From June 1862 the exhibition opened on three evenings a week from 7 to 10 p.m., with a reduced price for admission and a special small catalogue. After the move to Burlington House in 1869, evening opening was replaced by an extra week at the end of the season with reduced entrance and catalogue charges. When Sir Frederick Leighton became president in 1879, the summer exhibition reopened in the evening in the last week and stayed open continuously on the last day from 8 a.m. until 10.30 p.m. The National Gallery made even less effort. The plea of the 1836 Commission that it open on summer evenings for the 'laborious classes', raised no response until 1885, when opening hours were extended from 6 till 7 p.m. from May to August. The official reason was that gaslight would damage the paintings and electricity was unreliable, but the real one was concern that the wrong kind of person might use the gallery for shelter. The Director's Report for 1879 says that

> with regard to the extension of the hours of public admission to the Gallery during the summer months, the Trustees and director are unable to persuade themselves that it would be attended with any beneficial results. They believe that that class of the public in whose favour the proposition has presumably been made would the least avail themselves of it if put into practice.

An 1886 report into the use of electric light pointed out that

> the neighbourhood in which the Museum happens to be situated is one which could lead to the rooms becoming, especially on cold and wintry nights, the resort of a class of persons whose presence would be most undesirable. . . . On the other hand there is much reason to doubt that the class of the public in whose behalf evening opening is demanded would take any extensive advantage of the privilege.

The plea for catalogues also fell on stony ground. Catalogues were to be had, but the sixpence and shilling charge for the informative handbooks published by Henry Green Clarke which

enlightened visitors to London's museums and galleries from the 1840s to the 1860s show that they were not aimed at the working classes, while the Royal Academy's catalogue at one shilling and the National Gallery's at sixpence were also well beyond their pockets. Decades later the plea was still heard. In 1884 the *Magazine of Art* suggested that catalogues indicating the distinguishing characteristics of the artist and classifying and dating the pictures would help the people understand what they were being offered, and Walter Besant complained that 'It is not enough, in fact, to exhibit pictures: they must be explained. It is with paintings and drawings as with everything else, those who come to see them, having no knowledge, carry none away with them.'[4]

Despite the slow start, increasing numbers of the poor did find themselves in front of paintings from the 1870s onwards. But this had little to do with the galleries, who only acted when pushed. The efforts came from the amateurs, from pressure groups like the Sunday Society set up to 'obtain the opening of museums, art galleries, libraries, aquariums and gardens on Sundays' and from organisations founded to encourage the lower classes (mainly thought of as male in these cases) to pull themselves up culturally and educationally by their bootstraps. While not one of the reading rooms, mechanics institutes, mutual improvement societies or working men's colleges was founded to show pictures to the poor, the practice fitted in with their goals. When in 1862 the Working Men's Club and Institute Union set out to add a recreational element to the education of the working man, its programme included visits to stately homes, places of historic interest and, on one occasion at least, to an art gallery. The outing is recorded in a *Graphic* illustration of 6 August 1870 entitled 'A Party of Working Men at the National Gallery' (Figure 6.1). Editors always seized on the working classes absorbing culture as a good subject for an illustration. At the end of the decade, Sir Coutts Lindsay, founder of the Grosvenor Gallery, collaborated with the Sunday Society and opened one Sunday. The occasion was illustrated in *The Graphic* of 8 February 1879 by two drawings carefully chosen to tell a tale. Neatly dressed families viewing paintings in 'A Sunday Afternoon in a Picture Gallery' (Figure 6.2) were favourably contrasted with a group of drunks in 'A Sunday Afternoon in a Gin Palace' (Figure 6.3).

The nineteenth century witnessed a huge increase in the numbers anxious to better themselves. In the 1880s, the *Pall Mall Gazette* published a guide to the National Gallery. Its subtitle, 'Half Holidays at the National Gallery', revealed its target as waged

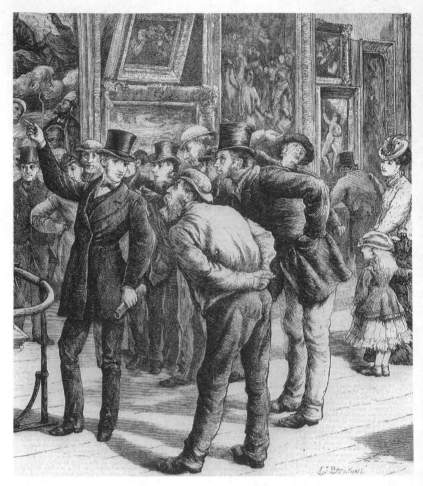

Figure 6.1 'A Party of Working Men at the National Gallery', *The Graphic*, 6 August 1870

workers with a free half-day each week, and advertisements called it the first cheap 'popular' guidebook. For sixpence, the visitor was given over eighty illustrated pages comprising a catalogue, descriptive notes and a scheme of twelve half-holiday tours arranged in historical sequence. The guide assumed literacy, motivation for self-education, and a willingness to part with sixpence in the cause of culture, and it was right to do so, judging by the number of editions it went into. By the end of the century, a structure existed for those who wanted to climb their way up into culture.

But though the nineteenth century broadened the band of the

culturally sophisticated, there remained at the bottom those who had never seen a painting and, if they did, were not likely to look for its meaning in a book of half-holiday tours. The voluntary organisations also took responsibility for these outsiders, deciding in the 1870s that the only way to reach them was to take the pictures to them. In 1878, the arena where art was to fight was revealed in a catalogue to an exhibition set up in Blackfriars by the Sunday Society.

> One Sunday afternoon, the painter of these pictures of Switzerland was mooning along one of the most crowded and poorest thoroughfares in London when he heard a fine-looking navvy, very trim, and who had just been enjoying a clean shave, address some of his friends across the street.
> 'Well, Jim; how air ye? What air ye up to – busy?' Jim replied with a wink, and pointing with his thumb to a public house behind him, with closed doors, whose clock was near the hour of opening, 'Shall be busy enough directly.'

When the artist found a crowd looking at pictures in a tobacconist's window, he was struck by the Utopia to be brought about by looking at art:

> The artist said to himself, 'Oh that another Peabody would devote his fortune to building galleries in the very poorest quarters of London and manufacturing towns, which should open free. With what alacrity would many rich collectors lend some of their treasure if they could only see for themselves the humanising effect on the crowds who would visit them.'[5]

The following year the suggestion that pictures should be taken to the poor appeared in *The Times* and on 21 March 1879 the *Daily News* carried a letter from the Sunday Society president Lord Rosebery requesting 'some temporary Sunday art exhibitions in the poorer districts of the metropolis, where the refining influence of Art would come as sunshine to thousands of our countrymen on their weekly day of rest'.[6]

In August 1879 this exporting of culture to the poor was put into practice when William Rossiter opened a loan exhibition in two rooms of his South London Working Men's College, 143 Upper Kennington Lane, which he claimed as South London's first-ever exhibition of fine art. Evening and Sunday afternoon opening showed that he was trying to draw in the local population and early evening opening for children was introduced halfway through the show. He was so pleased with the almost 4000 visitors

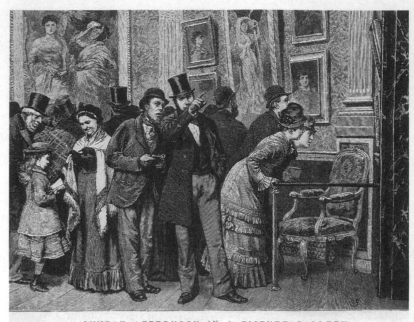

A SUNDAY AFTERNOON IN A PICTURE GALLERY
DRAWN FROM LIFE

Figure 6.2 'A Sunday Afternoon in a Picture Gallery', *The Graphic*, 8 February 1879

that he put the show on again in 1880 and twice in 1881.

Although the Sunday Society concentrated on getting existing galleries to open on Sundays, at the end of the 1870s it set up its own exhibitions in poorer areas. Following its show of William Thomas's paintings of Swiss life, it made other attempts to get out of the West End where most of the galleries it persuaded to open on Sundays had their premises. In 1879, the Society put on a loan show at the Aldersgate Gallery of Paintings to prove that Sunday opening in the city would draw the crowds. In 1880 it mounted another city show, this time in Bishopsgate, of watercolours lent by South Kensington and works by City Art School students.

Samuel Barnett's first exhibition in 1881 came at the end of this series of toe-in-the-water experiments. He knew about the Sunday Society's efforts since he had been connected with it from its foundation and had preached a sermon in support of its objectives in 1877. He must have known about Rossiter's exhibitions since the Society supported them: its secretary had written to the *South London Press* asking for funds to defray the costs of Rossiter's 1879 exhibition, which, he said, was doubly useful for being held

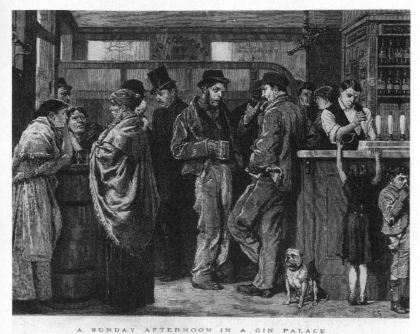

A SUNDAY AFTERNOON IN A GIN PALACE
DRAWN FROM LIFE

Figure 6.3 'A Sunday Afternoon in a Gin Palace', *The Graphic*, 8 February 1879

in the centre of a densely populated area and for remaining open on Sunday.

There was, however, a world of difference between Barnett's show and its predecessors. The Sunday Society must have repelled as many visitors as it encouraged, due to its policy of limiting entry to those who applied by letter and included a stamped and self-addressed envelope for their tickets. Given the low literacy level of the period, it is unlikely that many of the East End poor wrote for tickets. An exchange of insults between Rossiter and a columnist of the *South London Press* reveals that Rossiter's show was not as grand as it sounded. Undistinguished dark-brown paintings and portraits of politicians were crammed together on benches, tables and floors, as well as hung on the walls, and little was done to disguise the classroom aspect of the rooms. Rossiter's lack of style and flair – there was no opening fanfare, no gallery talks, no Morris fabric on the walls – makes his shows shabby forerunners of the Whitechapel operation.

PART II

The Experiment

The experiment

On Saturday 14 April 1881, readers of the *Tower Hamlets Independent* were faced with a two-inch-square advertisement headed 'Fine Art Exhibition' (Figure 7.1). It announced that pictures by Royal Academicians and embroidery, pottery and scientific instruments from Her Majesty's Science and Art Department would be on show every day from 14 April to 22 April at St Jude's Schools, Commercial Street, for a three pence admission fee. Sir Frederick Leighton, the president of the Royal Academy, was one of the artists whose work would be shown and the Earl of Rosebery was to perform the opening ceremony. Stretched across the bottom of the advertisement were the words: 'every object will bear a full description.' The artistic and aristocratic worlds on offer in this advertisement far outclassed those of its neighbours in which the Pavilion Theatre announced a double bill of *The Bellringer of Notre Dame* and *The Stolen Jewess*, Bromley-by-Bow workhouse advertised for a clerk, Mr Shelton Swann sought pupils for the organ pianoforte and the Mile End New Town Working Men's Society listed members' donations to a local hospital.

The organisers pulled out all the stops to get the East Enders into the gallery. 'Many plans of advertisement' were tried out to attract the illiterate, a band played in the school yard to lure the poor through the turnstile, members of the exhibition committee made speeches in the street while others took up the job of 'chuckers-in'.[1] Despite opposition from the Lord's Day Observance Society, which sent men to threaten intending visitors to the exhibition with some awful future punishment – a toothless threat considering the church's lack of influence in the area, a lack the exhibition was intended to remedy – the exhibition stayed open on Sunday.

When the exhibition closed ten days later, ten thousand of the East End poor had passed through the turnstiles to see the scientific

FINE ART EXHIBITION.

PICTURES BY
Sir F. Leighton, P.R.A., Watts, R.A., Marks, R.A.,
Walter Crane, Burne Jones, &c.

EMBROIDERY.
W. Movus, Oriental and Old English.

POTTERY.
De Morgan, Doulton, Oriental and Old English.

SCIENTIFIC INSTRUMENTS.
Her Majesty's Science and Art Department.

Every object will bear a full description.

The Exhibition will be opened by the Earl of Rosebery,

On *APRIL* 14th, *to remain open daily until
APRIL* 22nd,
AT

ST. JUDE'S SCHOOLS, COMMERCIAL STREET

ADMISSION, 3d.

Figure 7.1 Two-inch display advertisement for the first Whitechapel Loan Exhibition, from the *Tower Hamlets Independent*, 2 April 1881

instruments in glass cases, the pottery by William de Morgan and the paintings by the finest contemporary British artists. They had been lectured to by the vicar of St Jude's, the Rev. Samuel Augustus Barnett, who had stood on a school bench so that everyone could see him as he expounded on the meanings contained in the paintings – meanings, it must be said, that had more to do with Barnett's Christian view of life and his dream of getting the Whitechapel poor to share it with him than with anything the painters might have intended.

When the results were assessed, the experiment was pronounced a success. The entrance fee was abolished, leading to an almost threefold increase in visitors the following year, and a decision was made to leave out the objects, which had turned the schoolrooms into a mini-museum, and show only paintings. And for the next seventeen years, until 1898, the Whitechapel Fine Art Exhibition was a fixture of the East End spring. In 1901 it was reborn in

permanent form as the Whitechapel Art Gallery, built on Barnett's initiative as a permanent home for art for East Enders. Though they were not aware of it, the visitors to the first exhibition were in at the birth of an experiment. Its organiser, the Anglican vicar of St Jude's, Whitechapel, religious, rich, and renowned today as the founder of Toynbee Hall, was giving the most dramatic form that had yet been seen to the belief that fine art had a part to play in solving the problem of the poor that so worried the reformers of the century's last three decades.

The man behind the move to bring the country's finest modern pictures to the poor was born Samuel Augustus Barnett on 8 February 1844 to a family whose money came from the manufacture of iron bedsteads. After leaving Oxford, he became curate at St Mary's, Bryanston Square in 1867 and then vicar of St Jude's, Whitechapel, from 1873 to 1894. From 1884 to 1906 he was Warden of Toynbee Hall in Whitechapel, the country's first and most famous settlement house which was in part inspired by him and which was in its turn an inspiration for hundreds of others round the world. He was Canon of Bristol from 1893 to 1906, Canon of Westminster from 1906 to 1913 and Sub-Dean of Westminster in 1913, the year he died. In 1873 he married Henrietta Octavia Weston a wealthy 19-year-old aide to Octavia Hill. She was the perfect partner. Energetic, practical and friendly, she was more worldly than he and less saintly (Figure 7.2).

Henrietta Barnett says the first exhibition grew out of a parishioner's suggestion that they display their souvenirs of a recent trip to Egypt. Others credit T. C. Horsfall with the idea. But however it began, its continuation was Barnett's own work. He rarely imparted any art history to the visitors or educated them in aesthetic appreciation, and he had no interest at all in letting them get their hands on a paintbrush. He concentrated on refining them by pointing out the lessons to be learned from the images. Pictures of mothers and children were presented to the Whitechapel unwashed as examples of model family life, and landscapes were used to sow discontent with the filthy East End streets.

By the second year, the pattern was set. The exhibition was held every Easter, lasting two weeks for the first few years and three weeks after 1886. It stayed open twelve hours a day, seven days a week, from 10 a.m. until 10 p.m., to enable visitors to get there after work, and it was free. It was held in the school attached to the church. For the first few years the pictures were crammed into three dark schoolrooms measuring 30 × 60 feet, and the visitors urged to come by daylight (Figure 7.3), but in 1886 a generous gift

Figure 7.2 Henrietta and the Rev. Samuel Barnett in 1883, the year of the third Whitechapel loan show

from well-wishers enabled three large light rooms to be added on to the back of the school.

The worldly Henrietta understood the importance of publicity, and every year a famous person would address the helpers and well-wishers at the opening ceremony. The press was always invited to hear the speech, and the combination of famous speaker, well-known well-wishers and novel experiment of bringing art to the unwashed guaranteed a large number of column inches in the national as well as the local papers. The willingness of the rich, the important and even the royal to come to Whitechapel says much for the status of art and also the status of the Barnetts' experiment, a status which gained immeasurably from the couple's, and particularly Mrs Barnett's, talent for public relations.

The shows were mounted by an efficient voluntary committee whose members took responsibility for specific areas. Mrs Barnett described how with the school free of students for only seventeen days in the Easter holidays, the preparations had to be crammed into the first four: 'On the Thursday before Maundy Thursday the school broke up. On Friday and Saturday the pictures were collected. On Saturday afternoon and Sunday the catalogue was written. On Monday the pictures, 300 to 350, were hung.'[2] The hanging committee saw that the pictures fitted into the available

WHITECHAPEL
FINE ART EXHIBITION

WILL BE OPEN IN

ST. JUDE'S SCHOOLS,
COMMERCIAL STREET, E.

From MARCH 28 to APRIL 12,

DAILY, from 10 a.m. to 10 p.m., SUNDAYS, from 2 to 10 p.m.

PICTURES BY

Sir F LEIGHTON, P.R.A	G. F. WATTS, R.A.
J. ISRAEL.	T. FAED, R.A.
H. HERKOMER, R.A.	J. BRETT, A.R.A.

And other Artists, will be shown.

ADMISSION FREE.

COME BY DAYLIGHT IF POSSIBLE.

Figure 7.3 'Come by daylight if possible.' Advertisement for the fifth Whitechapel loan show in the *Tower Hamlets Independent and East London Advertiser*, 28 March 1885

space. The decorative committee arranged for the loan of fabrics to transform the schoolrooms. The advertising committee placed display advertisements in local newspapers and arranged for handbills to be printed. The watch committee hired the caretakers, policemen and firemen and persuaded twenty or so gentlemen that they would enjoy doing a four-hour watch in the rooms. The young William Rothenstein was a watcher at the end of the 1880s and has left a view of what the East End meant to the educated at the end of the nineteenth century:

The Barnetts were also beginning to organise exhibitions of paintings with the warm support of Watts, Burne-Jones and Holman-Hunt, who freely lent their pictures. The Barnetts had, I fancy, but slender funds at their disposal, on which account we acted by turn as wardens while the exhibition was on. . . . I also spent an evening each week in a boys' club in Leman Street, the Whittington Club, where I taught drawing and modelling. To become a worker in Whitechapel seemed an adventure; the East End was a part of London remote and of ill repute, which needed missionaries, it appeared, and it flattered my self-esteem to be one of these. . . . These activities were rather worrying to my parents; it was the time of the murders by Jack the Ripper, and Whitechapel had a sinister sound to provincial ears. As a matter of fact, I came into touch this way with many fine and enlightened people.[3]

The exhibitions were run on a shoestring. Major expenses were for transporting the paintings to and from Whitechapel, insuring the works (the fifty paintings lent by Alexander Young in 1893 were insured for £50,000), paying the hangers and the night watchman to protect the paintings from theft and fire, and printing the catalogue. Since they were held in the church school, no rent had to be paid. The paintings were loaned and so were the draperies to hang them against. Lighting was supplied free by the Commercial Gas Company and the gallery guides lectured for love.

Even so, about £100 to £150 was needed to mount the exhibition, and a deficit of £50 was regularly carried from year to year. Appeals for funds to meet it were a regular feature of opening day ceremonies. Gifts from well-heeled sympathisers accounted for the largest part of the money raised but sales of the penny catalogue brought in a respectable amount rising from £19 in 1882 to £90 in 1896. An additional source of income came from the boxes placed round the schoolrooms for the public's pennies, their presence always mentioned in the catalogue in case the visitors overlooked them. A photograph shows that the custom continued into the early years of the Whitechapel Art Gallery (Figure 7.4). However, the dropping of the entrance fee after the first year shows that when forced to choose between spreading his message or gathering funds, Barnett always chose the former.

The biggest headache was getting the pictures, a task made doubly difficult by Barnett's desire not just to show the best of contemporary art but to show it only once. Although a circular was printed to ask for pictures and national newspaper reports

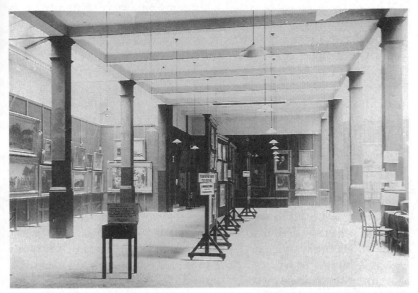

Figure 7.4 Interior of the Whitechapel Art Gallery, early 1900s. The notice in the left foreground reads, 'Owners have lent their pictures, the Gallery has been given. If visitors will put a coin in the box the expenses will be paid and other Exhibitions be POSSIBLE.'

kept the exhibitions in the public eye, the majority of pictures came from personal appeals, from the persistence and scope of the Barnett's demands, and from their willingness to handle the transportation of the pictures to Whitechapel and back. The committees they sat on dressed in their social reformers' hats, and the dinners they attended in the course of a crowded social life, provided a huge bank of potential lenders.

Although odd sentences in Barnett's weekly letter to his brother suggest that quality was sometimes a problem, quantity rarely was. In fact until the rooms were added in 1886, when a giant show of 350 pictures celebrated the extra space, the catalogue always carried an apology for the inability to hang all the pictures received. Only once did bare walls seem a possibility, and that was in 1893 when most of the best British pictures had been sent off to the World's Fair in Chicago. On 24 February Barnett wrote to his brother that 'pictures come in slowly'. Two weeks later he wrote triumphantly, 'we have a haul which I hope will make the show, some Corots and some fine Israels.'[4] In between, Alexander Young had promised to lend fifty of his contemporary French and Dutch works of landscape and rural genre.

The shows were of an extremely high quality. Practically every major British artist of the era was represented, frequently by works that had hung at the Royal Academy's summer exhibition. Burne-Jones's four paintings of the Legend of Briar Rose were shown in 1891, the year after he finished painting them. Leighton's *Hercules Struggling with Death for the Body of Alcestis*, seen at the Academy in 1871, was seen by the East Enders in 1885, the same year as they saw Herkomer's *The Last Muster*, the picture of the year at the 1875 Academy. Holman Hunt's *Strayed Sheep* and *The Light of the World* shown at the Academy in 1852 and 1854 respectively were shown at Whitechapel in 1883. All the art was academic in style. Barnett either did not know or was not interested in the fact that the more advanced British artists were beginning to be lured away from Victorian literalness to French Impressionism. William Rothenstein, a watcher who had felt the draw of the new style, was given charge of the room containing Holman Hunt's *Massacre of the Innocents*: 'I had plenty of time to examine this strange picture. I found it difficult to understand the literal representation of a subject so remote from credible human experience. Its cruelty had no appropriate symbolic excuse, and might well cause doubt in the mercy of Providence.'[5]

Although the majority of pictures were by contemporary British painters, the occasional old master and contemporary works by highly regarded foreign artists were also shown, enabling the Whitechapel poor to see a Rubens landscape, several works by Turner, Canaletto's *The Doge's Palace, Venice*, a Rembrandt and portraits by Reynolds and Gainsborough. Obviously with between 200 and 300 pictures in a show, not all could be what Mrs Barnett called 'gems of contemporary art'. Sometimes paintings were included for reasons other than quality, like the twenty scenes of North America hung in a group in 1887 and introduced in the catalogue as 'of interest to any who contemplate emigrating to those countries'. On one point they were adamant: there was to be no amateur art. An East End mother offered Barnett a portrait done by her son, and Henrietta put the episode into Barnett's biography to show how his devotion to maintaining the highest standards was not always appreciated or understood by the locals. Craft work by artisans had been exhibited for years at the local industrial exhibitions, and work made by the Guild of the Brave Poor Things, an organisation of the crippled, was shown by the Bermondsey Settlement in the 1890s, but the Barnetts never wavered in their belief that craft could not be art.

The new social realism was another outlawed area. Wherever

possible, Barnett chose pictures that suggested the higher side of life, in support of his belief that art was the greater for avoiding the picturing of harsh and depressing realities. 'Artists don't look at facts to find truth,' he wrote to his brother. 'Those who do look at fact, like Zola, look to find horror and sensation.'[6] Fildes's *Applicants* and Holl's *Newgate* were owned by Royal Holloway College, Egham, from the early 1880s. Perhaps it refused to lend them, but more likely it was not asked, since Barnett liked realism seen through a vaseline-smeared lens. In 1885 James Staats Forbes, the uncle of the painter Stanhope Forbes, sent seven works by the Newlyn artist Walter Langley and eleven works by Israels. Barnett fully approved of such pictures: 'Forbes certainly has a bit of tender social sentiment and this comes out in his love of Israels, Corot, Millet etc.'[7] A few of the paintings, like Frank Baden Powell's *All Kinds and Conditions of Men as Seen on the Thames Embankment*, listed in the 1885 catalogue, sound as if they might fit into the new social realism category, but given the unshakeable Victorian appetite for puns which reveals John MacWhirter's *Out in the Cold* to be a donkey shut out of its stable, one cannot be sure. Watts's 1840s paintings of social comment were exhibited at the Grosvenor Gallery in 1881–2 but they were not seen at Whitechapel in that decade, even though many others by him were. E. R. Clifford's *East End boy in the Hayfields*, while topical, was presumably not a pessimistic image since it was described in the catalogue as the artist's idea of what the Children's Country Holidays scheme, which had been set up by the Barnetts, set out to do.

The list of lenders was as starry as the paintings they lent. It included Royal Academicians, philanthropists like Baroness Burdett Coutts and Henry Tate, picture dealers, members of parliament, churchmen and the nobility, culminating in Queen Victoria herself, who lent three pictures in 1887, the year of the Diamond Jubilee, and two in 1889. Not everyone lent pictures every year, but certain names crop up more frequently than others, suggesting the existence of a core of reliables who could always be trusted to produce a picture or two. Most people contributed between one and ten works to a show. G. F. Watts, whose idiosyncratic eyes looked kindly on efforts to improve the lot of the poor, lent pictures nearly every year, eleven in 1886 and eighty in 1897. The socialist Walter Crane sent pictures regularly in the 1880s and Henry Holiday, a socialist sympathiser, sent two pictures in 1887 and one in 1891.

While getting the pictures would have been enough for most

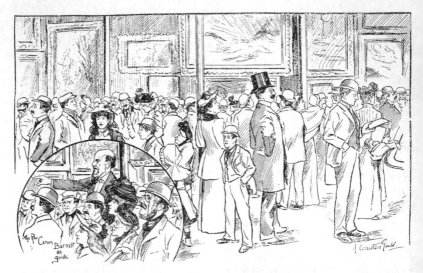

Figure 7.5 Sunday afternoon at the Whitechapel Art Exhibition with (inset) Samuel Barnett standing on a bench to lecture. Newspaper illustration reproduced in *Canon Barnett: His Life, Work and Friends*

organisers, the Barnetts put as much effort into making the show a success after its opening. Much thought was given to how to channel the visitors, a problem in the early years because of the limited space and in later years because the number of visitors increased so dramatically. As well as canny distribution of canvases to avoid a pile-up of people, the educated young men with a fashionable social conscience who made up the voluntary watchers ensured that the visitors kept moving, encouraged them to buy catalogues, answered questions and forbade smoking, sticks, umbrellas, raised voices and children playing.

Channelling was not just to avoid traffic jams and accidents to the pictures, but to help Barnett and his helpers preach about the paintings. Once the crowds were controlled, gallery talks, voting for favourite paintings and explanations in the catalogue held their interest. Barnett loved taking advantage of what seemed to him outstanding opportunities for preaching: 'Sometimes I wish I did nothing all the time but remain there going the round and making them familiar with the pictures.'[8] 'At first he talked with the crowd pressing round him,' recalled his wife. 'But as many hot breaths and unclean clothes were not helpful, he was persuaded to stand on the school forms, or on chairs placed in appropriate places'[9] (Figure 7.5).

For the people coming in from the streets of crowded, dirty,

built-up Whitechapel it must have been a revelation to see costume dramas, landscapes and gentle scenes of distress on the St Jude's schoolroom walls. The language of art, which can make a Poussin so puzzling to the untrained and uneducated, was at its simplest in the Victorian age. For every allegorical work by Watts, there were ten of domestic interiors, pathetic family scenes or episodes from history that looked as if they were being performed by actors. In terms of inspiring spectator response, the academic art of nineteenth-century England is among the least daunting of any period, foreshadowing at times in its literalness the silent films which were to follow on its heels.

8

Sugar-coated sermons

The newspaper advertisement for the first exhibition carried the words 'every object will bear a full description'. By 1882 this 'full description' had become the catalogue.

The catalogue was Barnett's special project and he threw himself wholeheartedly into its composition. The information it contained had nothing to do with the finer points of art appreciation. It was a way – the most important way along with the gallery talks – of preaching the moral values he believed in to the poor. He wrote:

> It is impossible for the ignorant to even look at a picture with any interest unless they are acquainted with the subject; but when once the story is told to them their plain direct method of looking at things enables them to go straight to the point, and perhaps to reach the artist's meaning more clearly than some of those art critics whose vision is obscured by thought of tone, harmony, and construction.[1]

Barnett's conviction of the importance of the word as bridge between paintings and the poor was expressed in the advice he gave on mounting an exhibition: after amassing the collection, make the catalogue, 'remembering the oft quoted dictum that the best exhibition is that which illustrates the catalogue'.[2]

His belief in pictures as sugar-coated sermons was encouraged by his total lack of aesthetic appreciation. Charles Aitken, the first director of the Whitechapel Art Gallery, wrote that

> though it was not through the eye of the aesthetic faculty that he himself obtained inspiration most readily, he wisely resolved to press art into the service of the causes he had so much at heart. Thus by a curious paradox, the man in our generation who perhaps has done most for lovers of art and for art itself by

striving to obtain for art that wide public which all great art requires for healthy activity, was not himself one who was moved most strongly to aesthetic emotion.[3]

Before his marriage Barnett confessed his blind spot to his bride-to-be: 'This century expects every man to understand and worship art, so we all talk a little about it. I am conscious of failure really to value it.'[4] He never learned, writing uncomprehendingly about the Rokeby Venus in the late 1890s, that 'people talk of its beauty and form'.[5]

His philistinism was encouraged by an optical defect: Samuel Barnett was colour-blind. Describing his approach to writing the catalogue entries, his wife rather meanly recalled that 'some of his descriptions did require free editing, for his colour-blindness made him unable to discern beauties that needed to be indicated, and his extravagant optimism tended to endow some artists with intentions other than their own'.[6]

Lack of time and the impracticality of ending up with a three-volume catalogue meant that not every painting in the show was given a catalogue description. He picked the ones which lent themselves to the message he wanted to get across. Reading the catalogue comments is a revelation of what Barnett believed and what he believed paintings could do towards refining the poor's view of life (Figure 8.1). In their woven teaching and preaching, Barnett's values appear in innocent nakedness.

The few paintings with references that might be familiar to the Whitechapel visitors were seized on for comment. J. Charles's *Inmates of the House* was shown in 1886: 'the dear old ladies ought all to be at home, teaching the young children lessons of reverence and gentleness; but "someone has blundered" and so they are lonely, though all huddled together, in the "House", glad of the shelter which the people's conscience has provided.' From this knot of conflicting attitudes can be extricated a vision of the world as it should be, an awareness of distress and an inability to accept that everything might not be for the best. The moral was underlined in A. W. Bayes's *The Return of the Wanderer*, shown in 1887: 'A wayward girl returning at early morn from a fancy dress ball, dressed as "Folly", finds her mother dying in a garret. The priest turns from the dead woman, whose life has opened upon a new day, to give comfort and consolation to the heart-broken girl whose days also will now open upon a new and better life.' However, neither of these paintings sounds as revealing of Whitechapel life as the comment Henrietta Barnett reports was

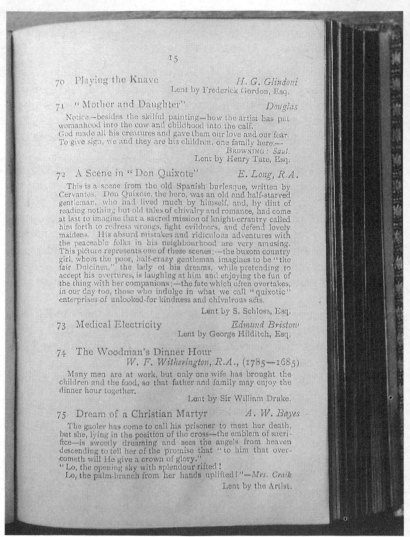

15

70 Playing the Knave *H. G. Glindoni*
 Lent by Frederick Gordon, Esq.

71 " Mother and Daughter" *Douglas*
 Notice—besides the skilful painting—how the artist has put
 womanhood into the cow and childhood into the calf.
 God made all his creatures and gave them our love and our fear.
 To give sign, we and they are his children, one family here.—
 BROWNING : *Saul.*
 Lent by Henry Tate, Esq.

72 A Scene in " Don Quixote" *E. Long, R.A.*
 This is a scene from the old Spanish burlesque, written by
 Cervantes. Don Quixote, the hero, was an old and half-starved
 gentleman, who had lived much by himself, and, by dint of
 reading nothing but old tales of chivalry and romance, had come
 at last to imagine that a sacred mission of knight-errantry called
 him forth to redress wrongs, fight evildoers, and defend lovely
 maidens. His absurd mistakes and ridiculous adventures with
 the peaceable folks in his neighbourhood are very amusing.
 This picture represents one of these scenes;—the buxom country
 girl, whom the poor, half-crazy gentleman imagines to be "the
 fair Dulcinea," the lady of his dreams, while pretending to
 accept his overtures, is laughing at him and enjoying the fun of
 the thing with her companions;—the fate which often overtakes,
 in our day too, those who indulge in what we call "quixotic"
 enterprises of unlooked-for kindness and chivalrous acts.
 Lent by S. Schloss, Esq.

73 Medical Electricity *Edmund Bristow*
 Lent by George Hilditch, Esq.

74 The Woodman's Dinner Hour
 W. F. Witherington, R.A., (1785—1685)
 Many men are at work, but only one wife has brought the
 children and the food, so that father and family may enjoy the
 dinner hour together.
 Lent by Sir William Drake.

75 Dream of a Christian Martyr *A. W. Bayes*
 The gaoler has come to call his prisoner to meet her death,
 but she, lying in the position of the cross—the emblem of sacri-
 fice—is sweetly dreaming and sees the angels from heaven
 descending to tell her of the promise that "to him that over-
 cometh will He give a crown of glory."
 "Lo, the opening sky with splendour rifted !
 Lo, the palm-branch from her hands uplifted !"—*Mrs. Craik*
 Lent by the Artist.

Figure 8.1 A page from a Whitechapel loan show catalogue. No. 71, 'Mother
and Daughter', reads, 'Notice – besides the skilful painting – how the artist
has put womanhood into the cow and childhood into the calf.'

made by more than one visitor before Munkacsy's *Lint Pickers*,
that they thought it was a lot of Whitechapel residents at tea.
 A great sadness to the Barnetts was their visitors' indifference to
the landscape paintings, a blindness they attributed to the eye-
deadening effect of the Whitechapel environment. Henrietta
explained how they tried to open the eyes of the poor to landscape

art by endeavouring 'to connect the landscape with some idea with which they were already familiar, or to connect it with some moral association which would attract notice to its qualities.'[7] Creaking attempts were made to link unlike with like. In 1884, the comment on the painting *Off the South-East Coast* ran: 'the barges laden with hay, which go heavily in the Thames, and whose cargo is sold in the Whitechapel High Street, are here dancing by the sea.' H. E. Bowman's *Evening on the Hills*, also shown in 1884, was described as 'A landscape such as may be found in Surrey, within twenty miles of Whitechapel', a comment uniting the horror that is Whitechapel with the wonder of the countryside.

The caption to Vicat Cole's *A Surrey Cornfield* shown in 1889 is an example of gentle propaganda for the countryside: 'Harvesting is hard work, but who would not exchange a stuffy Whitechapel factory for this breezy sunny down? And yet there are those who say that the country is dull.' The poor's lack of response to landscape worried other reformers. Besant noticed it at the Bethnal Green Museum where the visitors passed by the landscapes and portraits. 'What they love is a picture of life in action, a picture that tells a story and quickens their pulse.'[8] It was particularly distressing to Barnett since he believed that landscapes revealed the divine plan: 'The pictures of Vicat Cole do one good. . . . They in a mysterious way seem to incorporate our own identity and help one to forget that one is anything but a drop in a wave or a mote in a sunbeam. By them one enters into the life of the world.'[9] Judging by their comments, the Barnetts expected the paintings which glamorised London to meet with resistance. The comment to Clara Montalba's *London Bridge*, exhibited in 1883, runs, 'the artist shows us that there is more light and beauty near our doors than we see. There is a look of Venice in the picture.' A. Bayes's *Entrance to the Clothes Exchange (Houndsditch)*, exhibited in 1892, is captioned: 'A familiar bit of our own East London. Our friends will hardly recognise the bright colours in which the artist has painted the dingy Clothes Exchange. Yet the picture will serve to remind us that only a *desire* for beauty is needed to give Houndsditch something of the picturesqueness of Venice.' Naturally the Barnetts attempted to justify the picturesque cast the painters gave the capital, though it is hard to imagine what the visitors made of the explanation to W. L. Wyllie's *A Thames Scene*: 'Painters and poets do, indeed, see what other men see, but they "Look *through* their eye not with it" till they see far enough to add "the consecration and the poet's dream"'. The same artist's *London Bridge*, shown in 1892, was captioned: 'Few of the crowds

that hurry across London Bridge give a thought to the beauty of the river. The artist shows us, behind all the "wealth and smoke and noise" of London, the beauty that is never far off. Even to Cannon Street station and the steam colliers the sunset lends poetry; where some folks see only dirty water and dirty smoke the artist sees a picture.'

The Barnetts were in a position to be more aware than most of social sore-spots and the alienated state of the poor. Despite this awareness – or perhaps because of it – one of their self-appointed tasks was to defuse possibly incendiary dissatisfactions with society. This they did by directing visitors' outrage towards matters which neither affected them nor which could be affected by them. The comment to *Old Westminster Bridge*, shown in 1884, went: 'Much of old London is still left, and much more has since been added which is beautiful; but why are we not more careful to see that works of utility are also made beautiful? The Charing Cross Railway Bridge is hardly "a sight so touching in its majesty"'. 'He must have loved the river too, which was then, as it ought to be still, a pleasure resort as well as a commercial highway,' ran the comment to a Constable lent in 1884. Impeccable sentiments but surely academic to viewers whose everyday life was made up of poverty, illness, drink and dirt.

Sometimes half a page was spent on explaining the paintings with literary or historical subject matter, an eloquent testimony to the differing educational standards between classes. In 1884, Watts's *Ophelia* was rather sweetly captioned: 'Ophelia loved Hamlet, a man too weak to bear the burden of life. Her love found therefore nothing on which to rest and was too strong for her to bear by herself. She is telling it to the trees and the streams, and men call her mad.' The same year *Oedipus and Antigone* was given a Christian cast: 'Oedipus was King of Thebes and did a great wrong unwittingly. When he learned the truth, with his own hands he tore out his eyes, for that "it was not fit that the eyes which had seen such things should ever look upon the sun again." And not long after Oedipus was driven forth in wretchedness and beggary, and his daughter Antigone led him by the hands, and sought to cheer him in his agony. . . . And the story goes on to tell of the healing virtues of love; for in the end the furies of remorse are turned into the kindly goddesses of forgiveness and Oedipus is received up into heaven.'

Biographic information was rare, and tended towards the 'artist was the son of the poor man' variety, aimed at showing how even the lowest-born can rise above their disadvantages. Stylistic

information was also sparse. A. Melville's *French Shepherd* shown in 1884 was 'a picture in what is called the Impressionist school, the method of which is to put rapidly upon the canvas the general impression of any scene'. A rather fine attempt at describing Turner's *Off Calais* began, 'Turner was one of the greatest of landscape painters. He believed that it was the part of an artist to receive a strong impression from a scene, and then to try, as far as possible, to make the spectator of his picture receive the same impression. It is the depth of his sympathy with the *spirit* of the scene before him, that makes his landscape great.' It concluded bossily, 'Turner was very fond of painting Calais Harbour. He has done so five times. His paintings generally should be seen at a distance of ten or twelve feet.' But basically Barnett had no intention of wasting the opportunity to preach that the pictures offered. Art appreciation and art history were subjects taught at Toynbee Hall in the university extension lectures introduced in the 1880s, but only *he* could moralise on the pictures. He was much happier using stylistic information to make a moral point, as he does in 1887 with Rossetti's *Marigolds*: 'A typical picture in the so-called "aesthetic school", in a room in which all is perfect and beautiful harmony, even to the marigolds which repeat the colour of the girl's hair. Everything is in good taste, not because it has cost much money, but because it has cost much thought.'

What the Barnetts were imparting was not an aesthetic education but their vision of the perfect world. The outstanding feature of this perfect world is that there is always a backstop against disaster, as is shown by the 1883 entry for *Left in Charge*: 'The old grandfather is tired with watching and has fallen asleep, but the faithful dog is left in charge, and the baby will be safe.' The vision of a mutually caring society in which even the animals play their part could be called the Seamless Society, and the Barnetts used the paintings to preach about it and prove its existence. Paintings showed perfection attained.

The Barnetts were not naïve dreamers; their social work is evidence of their knowledge of East End life. But though they knew society was shoddy, they were kept going by a vision whose details emerge in the catalogue entries. Its foundation is the closeknit family, and the family's importance is everywhere stressed. F. D. Hardy's *Young Photographers* was shown in 1884: 'The greatest boon of the age', said J. R. Green, the historian and East Londoner, 'is cheap photography: it links scattered families – of which the little maiden counts pussy as part.' In 1887, family life is linked positively to imperialism in the explanation of a seventeenth-century

Dutch painting: 'At the mid-day meal, at the moment of saying grace. It is evidently a family where everyone lived, dressed, and prayed by rule and with obedience. Such was the secret of the patient industry which enabled the Dutch to protect their own country from the sea, and to conquer lands beyond the sea elsewhere.' No subject was too grand to be reduced to Whitechapel terms. A replica of Raphael's *Madonna del Cardellino* exhibited in 1886 was explained thus: 'In this woman there are the nobleness, and self-forgetting, ever watchful care of a true mother. In the children there are the friendship and the tenderness which are ever found in a true home.' The imperfect Whitechapel families were constantly shown perfect families: 'The great masters painted the Virgin and Child in likeness of the people they knew; in their eyes, every home had the possibility of the highest,' they were told by the 1886 catalogue. While this caption linked the Holy and East End families, a quotation from Ruskin which appeared on the inside cover of several of the catalogues encouraged the Whitechapel family to think of itself as a work of art: 'We cannot arrest sunsets nor carve mountains, but we can turn every English home, if we choose, into a picture which shall be "no counterfeit, but the true and perfect image of life indeed"'. Lessons in happy childhood were also given. In 1886 Jozef Israels's *The First Sail* was used to point out a vision of perfect childhood: 'The children have found new use for the "sabot" or large wooden shoe which is worn in Holland, and the sparkling waves are making merry with them. It is a picture of what child life should be. The virtue of children is to be intensely happy; so happy that they don't know what to do with themselves for joy, and dance instead of walking – like Louisa.' Then followed one of Ruskin's verses in celebration of childhood.

When considered in the light of the Barnetts' knowledge of the irreligion and imperfect family life of Whitechapel, these expressions of religion and family as the secret of a successful society reveal the Barnetts' utopia and the way they hoped to bring it about. Henrietta Barnett's essay of 1886, 'The Poverty of the Poor', shows an identical capacity for balancing real and ideal. Having devoted several pages to a painful and factual account of the impossibility of feeding an East End family on current wages, she concludes with a vision of the English love of home as:

> One of our hopes for the future; and not the least conspicuous as a moral training ground is the family dinner-table. There the mother can teach the little lessons of good manners and neat ways, and the larger truths of unselfishness and thoughtfulness.

There the whole family can meet, and from the talks over meals, during the time, which, as things are now, is perhaps the only leisure of the busy mechanic, may grow that sympathy between the older and younger people which must refresh and gladden both.[10]

This determination to fight a rotten reality with an ideal vision was shared by others in the Barnetts' circle. H. W. Nevinson worked at Toynbee Hall in the late 1880s and his book of short stories, *Neighbours of Ours*, published in 1895 and much admired by Barnett, shows a working class aglow with a tolerance, kindness and love which is the literary equivalent of Barnett's captions. Although the book deals with everything from infanticide to wife-beating, its comic tone and optimistic belief in good triumphing over evil make an interesting contrast with Arthur Morrison's *Tales of Mean Streets*, published a few months later, which gives a horrifying picture of working-class life. Doubtless there was a lighter side to Whitechapel life, but Nevinson's chirpiness does not ring true.

What causes unease about the Barnetts' catalogue comments is their bright affirmation that the world is fine, when if this really had been the case they would not have bothered putting on the exhibitions. The Barnetts' presentation of a perfect world could only be conducted by ignoring the cracks in society. Occasionally the real world creeps in, only to be denied, as in Jozef Israels's *The Sewing Class* exhibited in 1885: 'The old lady keeps order without noise or look, but the work of the girls is not slavery. They are all hard at work, but yet have their own thoughts the while.' Or the note to Watts's *The Curate's Daughter*: 'A good English home makes a good English girl. There have been no evil temptations to stir evil passions.'

The success of the Whitechapel catalogue meant much to Barnett and he mentions it frequently in his weekly letters to his brother, writing in 1884 that the 'people are coming well to the Picture Show and are greedy for catalogues . . . you would like to see the little groups who look, read, and then compare what they see with their own experiences.'[11] Although it is impossible to know whether the poor accepted the catalogue's message (though to people unused to pictures, anything said about them must have seemed right), thousands were sold. In 1882, 4,600 penny catalogues were sold to 26,492 visitors; in 1884, 11,000 catalogues to 34,291 visitors; in 1885, 16,000 catalogues to 47,713 visitors; in 1896 22,000 catalogues to 63,208 visitors. A newspaper printed

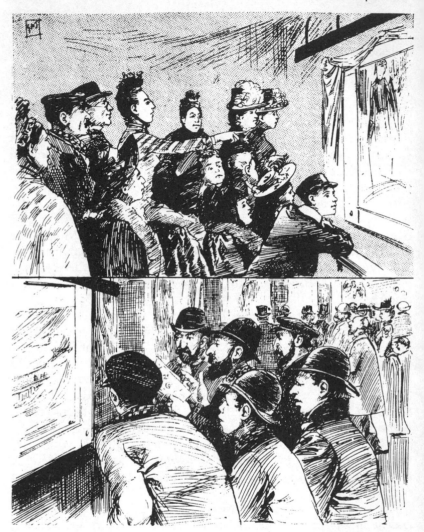

Figure 8.2 Newspaper illustration of the Whitechapel Art Exhibition, possibly the *Star*, 1880s or 1890s. A guide (top) explains the pictures to Board School children as well as adults. Below, a group of Jews have a painting explained to them by the one member of the party who speaks English and can therefore consult the catalogue

an illustration of a party of Jews studying the pictures and listening to the explanation being read from the catalogue by one of their group (Figure 8.2), and this evidence that catalogues were shared suggests that the ratio of one catalogue to every three visitors did indeed mean, as Barnett believed, that most people were exposed

to its message. Mrs Barnett tells of children reading the catalogue to their parents, a claim supported by the leaping child literacy figures of the 1880s.

It is easy to laugh at the Barnetts trying to put high thoughts into East End heads. But disarmingly, the Barnetts laughed first. The catalogue to the 1887 exhibition contains the caption, 'Notice, – beside the skilful painting – how the artist has put womanhood into the cow, and childhood into the calf.' And in her biography of her husband, Henrietta quotes the following comment against herself: 'It was worth a journey to East London, for the joke of hearing Mrs Barnett point out the motherhood in a cow's eye to a crowd of Whitechapel roughs.'[12]

Opening day speakers

Every year Barnett invited an important personality to Whitechapel to deliver the exhibition's opening address – William Morris in 1884, Henry Irving in 1891, the Archbishop of Canterbury in 1893, Lord Rosebery in 1881 and again in 1901 when he opened the first exhibition of the purpose-built Whitechapel Art Gallery. Though they came from a variety of fields, they were all part of the Barnetts' immense social and professional circles. National press coverage of the Whitechapel exhibitions from 1881, boosted by Barnett's position as warden of the world's first settlement house from 1884, ensured that the rich, the educated and the famous thought twice before refusing to come to Whitechapel.

The Barnetts were adept at marshalling these professional and personal friends and acquaintances who, once contacted, remained in the Whitechapel orbit for ever, put to work wherever aid was needed. For example, the painter William Holman Hunt helped out by attending parties for elementary school teachers ('We brought them face to face with Holman Hunt and other real creatures, people who know and unconsciously teach humility'[1]), by speaking at private view parties and by lending pictures almost every year. Hubert Herkomer opened his studio to Henrietta's Girls' Pupil Teacher Association, lectured on art, and painted Barnett's portrait for Toynbee Hall. The Marquess of Ripon became a Toynbee Hall associate, one of a group of 500 men involved in social reforms who gave their time and skills when able. William Morris prepared a green, red and gold colour scheme for St Jude's church, sent his firm's fabrics to dress up the schoolrooms as galleries, opened his home to Toynbee Hall's university extension students and was a guest at vicarage parties. A parishioner recalls meeting people 'we have heard of' at a

Whitechapel *conversazione*; Mrs Barnett's claim of 'daring social blending of East and West' was clearly not an empty one.[2]

The speakers' ideas on what art could do for the poor are very down to earth. There is a world of difference between Arnold's inspirational assertion that culture's sweetness and light could keep society on the straight and narrow and the speakers' attempts to justify opening school rooms hung with pictures to East Enders. For this reason, the views of the opening day speakers have an immediacy which is probably much closer to everyday thinking on these matters than the pronouncements of the sages which lay behind them. Some of the justifications for the value of art suggest a panic-filled previous night spent trying to think what looking at pictures could possibly do for the poor, or more precisely, since they all believed it could do something, how they could stretch this belief to fill fifteen minutes.

A strong smell of seriousness rises from the newspaper reports of the speeches. Barnett's exhibitions represented good works of the highest order and the speakers talked with earnestness, admiration and humility. They also agreed pretty much with one another from year to year, evidence of a consensus of ideas on art and the poor.

By the end of the 1880s, the Samuel Smiles mentality of expecting the poor to lift themselves up by their bootstraps was out of fashion among the enlightened. The Whitechapel speakers understood that the struggle for existence inhibited the development of life's refinements. They no longer expected the poor to travel to the National Gallery since, as Lord Rosebery explained at the first exhibition, travel was difficult, workers would shrink to enter unaccustomed palaces and their homes were isolated and far from the gallery districts.[3] There was much talk about setting up art outposts in the east, with one speaker feeling that the Whitechapel exhibit would enable East London to enjoy the treasures which West London had always at hand in the National and other galleries,[4] and Barnett recommending East London school buildings as temporary exhibition sites.[5]

The failings of the poor were referred to tactfully. Lord Rosebery said in 1881 that the rich must not harangue the workers on abstinence and thrift unless the workers were allowed to harangue back on luxury and selfishness.[6] E. N. Buxton refused to admit that the East End needed elevating; he could not see that the people from the West End, who had the benefits of art, were any more refined that those from the East End.[7]

There is a strong undercurrent of nervousness on the part of the upper classes about their possessions and position. The speakers

are forever hoping that the Whitechapel poor will develop friendly feelings towards the rich when they see the pictures they have loaned, a sentiment echoed by *The Times* in its report of the 1883 show on 26 March: 'It is something that in spite of our enormous social inequality they should see that the rich owners of pictures are ready enough to give a share in their pleasures to the poor,' it said hopefully. When Mr Mundella in 1895 contrasted the start of the century, when there had been no National Gallery, with the present, when art was taken to the 'very doors almost of the poorest',[8] the underlying assumption was that the rich had the ownership and therefore the disposing of art. In 1898 Sir Herbert Beerbohm Tree said with breathtaking tactlessness that not only was the sharing of pictures with the poor a survival of chivalry but that the pictures of the West End had gone to the East with the wise men.[9] Though few of the speakers would publicly label themselves wise men, even the most enlightened saw art's home as the West End. As Lord Rosebery said in 1881:

> What I like to see here is that some of the things that are best in our palaces have been brought here among the poor, and I trust that the effect on the many thousands who visit these schools in the next ten days will be such as to encourage those who come here to visit the treasures of art in her own dwellings in the West of London.[10]

Occasionally a specially sensitive speaker like Sir G. O. Trevelyan tried to deny the embarrassment of ownership by pretending that the rich were merely 'stewards for the benefit of others less favoured',[11] but the paternal overtones of keeping hold of the property until the minors come of age sounds even less appealing today than the others' honesty in facing the facts of ownership.

Most of the speakers came from the field of social reform, but a few were artists and it was they who did the feeblest job of linking art and the poor. Holman Hunt issued a diatribe on current bad taste, citing the 'clumsy bronze dummies' on Holborn Viaduct as an example, and then, unable to come up with any ideas about fine art's power to spiritualise, wrenched his speech round on to the conventional ground of better technical education for the artisan:

> The art world had been kept to a little section of society, but the sons of labour had a healthy instinct for art, and therefore he was glad to learn of the practical working that had been commenced by Mr Ashbee in the Technical Art School at Toynbee Hall, especially as he thought that, in the line of decoration, we might look for improvement in art.[12]

Sir Hubert Herkomer had even less to say about art and the poor, airing his views in 1894 on English art, which though an insight as to why modern French ideas on art took so long to take root in England, have nothing to say about fine art's refining powers. He deplored that 'a wave was passing over art which resulted in sensational and dabby painting'. He deprecated the fact that so many English students went to France and attempted to graft a foreign style on to their English natures. And he grumbled that all the English wanted were portraits.[13]

The other speakers stuck to the subject, illustrating it with a variety of points. Sir Herbert Beerbohm Tree supported his claim that the improvement of art and society had gone hand in hand with the dramatic but daft evidence that in the socially backward 1860s he had thrown an artistically backward specimen of the art of the period, in the form of a wax fruit glass case, out of a window.[14] Lord Herschell, with a more sophisticated understanding of what culture could be said to do for people, suggested that artisans who made bits of things needed art to expand their views and taste for higher life.[15] Despite the range, the speeches cohere into a body of theory that proved the existence of a fine art solution to the problem of the poor as it was perceived in the last two decades of the nineteenth century. *The Times* article mentioned earlier is a reminder of how hopeless East End existence seemed at the time:

> Without overvaluing the effect of Mr Barnett's experiment, it is easy to see what an event such a thing must be in Whitechapel. Few of us ever allow ourselves to dwell upon the life of the countless multitudes of our fellow-creatures who fill the East-End of London; if we did, we should almost yield to despair at the thought of the iron necessity which hems it in. What is to be done to amend and alter this state of things, which distresses the charitably disposed and perplexes the philosopher and statesman?

The key word in the fine art solution to the problem of the poor was 'elevate'. Barnett's conviction that art could bring the poor to religion was too extreme to be shared by any but the clergy, and they tended to be the supporting speakers and not the star attraction. Most speakers translated Barnett's goal of spiritualising into the secular version of elevating, refining and civilising. With the aid of paintings, the working classes could elevate their taste, their behaviour, their expectations of life, and even their lowly class status. The chasm between the classes could be diminished by

elevating the poor to a higher rung on the cultural ladder. However well-meant the desire to spread the joys of art, the wish to 'civilise' the poor through exposure to the pictures was always the reason behind it. At the first Whitechapel Art Gallery exhibition, Lord Rosebery discussed the chance of 'civilising a rough':

> If you offer this civilising agency, these rooms, this gallery, as a place where a rough fellow who has nothing else to do can spend his time, you offer him an option which he had not before and which if he avails himself of it cannot fail to have the most favourable results. You cannot test these things by mere results in figures. If you put £100 into an investment of this kind, you cannot have so obvious and direct a dividend. You can only sow a seed, believing and hoping that it will bring up its crop in time.[16]

Nearly every speaker stressed the refining power of art, presenting it as a 'good' pleasure to counteract the 'bad' pleasures of the masses. Art shows could draw the people from the low entertainment of public house and music hall, practically by offering a rival place to go or intellectually by uplifting the visitors' tastes. One way of achieving this uplift was by a sort of crude environmentalism: 'Animal and vegetable life is influenced by their surroundings,' said Beerbohm Tree in 1898.

> Thus the shepherd becomes like his sheep; the sparrow assumed the sober colour of the London streets; and he was convinced that the beauties of art would not fail to awaken the dormant qualities of those unfortunate people who never saw good pictures. Some artists revelled in the 'ugly' and convinced us by artistic wallowing that their productions were beautiful. But if we wished to elevate our minds, we must wander in the green lanes of picture land, and must not fill our minds with the shapes of Barnum's freaks.[17]

Another way art acted was by expanding the imagination of the poor, introducing them to scenes, emotions and ideas far removed from their everyday worries and concerns. Art's power was to sustain daily lives by widening the sympathies, deepening the emotions and introducing them to the grandest conceptions of mankind, said Leonard Courtney, adding that 'when they read a great poem, or saw a great picture, or heard a great strain of music, they felt, as it were, lifted above their peers and brought into communion with the greatest minds'.[18] The Archbishop of Canterbury felt that paintings could 'bring into the minds of our

industrious, sagacious and plodding people some of the brightness which a great end lends to the means thither, by training the eye and ear to avoid all that was base and low in life'.[19] Lord Herschell's view, expressed in 1896, that 'Today when men made not things but little bits of things the artisan could hardly be an artist and needed something to expand his views and a taste for higher life' was a typical expression of art's mind-expanding powers.[20] The more temperate Lord Rosebery subscribed to art's mind-broadening properties by saying in 1881 that

> the artisans of this neighbourhood, if they cannot at once appreciate the art-influences of these fine paintings, must regard them with the same kind of interest, when told they are the best of their kind, as will be felt by Sir F. Leighton, Mr Watts or Mr Millais on beholding a model engine whose machinery they do not understand.[21]

Another block of ideas concentrated on the power of art to relieve the dreadful monotony of the poor's way of life: 'And when we consider the efforts of people of fashion to arrest that feeling, what must be the monotony, the barrenness of the lives of the working and industrious compared with those in the enjoyment of luxury and wealth?' asked Lord Rosebery.[22] The Marquess of Ripon presented the hopeful theory in 1886 that the very drabness of their lives made the poor more susceptible to the beauties of art: 'Those as dwell in large numbers in the East of London were the best fitted to be penetrated and elevated by the imaginative and beautiful elements in works of art, because these were in greatest contrast to their dull and dismal lives.' Ruskin, behind so much of what was expressed, also crept into his speech:

> He was glad to see quoted on the catalogue the lines of Ruskin, life without industry is guilt, and industry without art is brutality, and he sincerely trusted that many would come there not only to study the pictures with advantage, but to obtain the pure light which only true art could shed on man's montonous existence.[23]

Lord Herschell said that both manual and intellectual workers were working classes in that work brought home a sense of monotony that lay on the spirit and created a thirst for rest and refreshment that art could slake.[24]

The group of ideas connected with the ability of art to educate reveals the upper-class fear of the political power of the poor. At the first exhibition, Lord Rosebery explained that

such an exhibition was the outcome of the movement now going on for the raising and bettering of the working classes, an unselfish object because it was connected with the idea that those to whom we have entrusted the great mass of political power of this country should be fitted, so far as lays within our means, to enjoy and exercise that power.[25]

The Marquess of Ripon, another who saw art's role in a wider and more sophisticated political context, was reported as saying that

to give the less favoured classes the best and purest of everything was the only sound principle on which they could hope to do much good in educational advancement, particularly in this part of London. In such movements, according to his judgement, a great deal of happiness and even safety of the country for the next few years depended.[26]

The use of the word 'safety' reveals that the unspoken reason behind the bringing together of rich and poor was the fear of what an alienated poor could do by political or physical means. Lord Rosebery said in 1881 that such exhibitions promote warmth and sympathy between classes who are otherwise estranged.[27] The pictures in the exhibition were a revelation of art for the well-to-do as well as the poor to enjoy in common, said Lord Herschell in 1896.[28] The fear of a mob with alien values is implicit in all the hopes invested by the speakers in the gift of art. But though avoidance of class warfare was a strong motive behind showing paintings to the East Enders, only one speaker actually put it into words. This was William Morris, who spoke at Whitechapel in 1884. In February and March of the previous year, Morris had read Marx's *Capital* in French, and it shows in his speech. Like everyone else he was unhappy about the condition of the poor and he shared his contemporaries' unease with the poor's crude behaviour and thought. But unlike the others, he said that he did not see how showing the poor pictures could improve current conditions. The exhibition organisers wanted to give workers an insight into the 'wondrous beauties of the earth in which they dwelt', but he wondered how workers enslaved by capitalism could receive such messages. To add insult to injury, he did not even think much of the art on offer, since he believed paintings were the art of an elite section of society and therefore meaningless to those not educated to appreciate it. Morris's reforming hopes for art needed a revolution before they could be activated. He believed that the condition of art depended on the condition of labour, and

since capitalism enslaved the poor to produce profits from manufactures, there was no chance for a good art to be produced. He told the audience that 'between the capitalist and workmen there was, and must be, a continual war going on', and not until capitalism was ended could there be that reverence for the life of man which he believed was the foundation of all art as well as of a decent society.[29]

Although his dream of a more spiritual working class brought him very close to the Barnetts, his belief that a revolution was necessary before this could happen moved him far away again. Like the other speakers, Morris gave his solution to the problem of the poor a cultural cast, but his particular revolutionary view of the matter was unique in this context and at this time in England.

It is hard to imagine what the invited audience made of Morris's pessimistic and, from their social and political points of view, extremely disturbing, marxist analysis of society. He was, after all, saying their approach would not work. *The Times* of 9 April 1884 commented frostily that Mr William Morris spoke 'in the tone to which he has lately accustomed us, of the evils of the existing social system and of the injury done to art and to life by a social order based not on co-operation but competition'. On the other hand, the *East London Advertiser* reported three days later that his talk was warmly received. Perhaps the self-congratulatory atmosphere generated by the achievement of bringing 300 pictures to the East End removed the sting from Morris's more provocative statements. Or maybe the invited audience chose not to hear what they did not want to, agreeing with his hopes that the poor must have pleasant houses, education, leisure and pleasure, but closing their ears to his embarrassingly excessive plea that they throw in their lot with the workmen. He was, after all, a famous figure by this time, and England has always allowed its eccentrics freedom of speech.

Getting in on the act

Barnett's first exhibition was a starting gun for all those involved in the world of putting pictures in front of the poor. Four months later, in August 1881, the Sunday Society organised a loan exhibition of modern paintings at the Working Men's College in Great Ormond Street. The organisers had looked long and hard at the Whitechapel show. Pictures which had previously been shown at the Royal Academy and at the Grosvenor, Suffolk Street and Dudley Galleries, replaced the customary Swiss watercolours, South Kensington loans and student work, with pride of place given to W. B. Richmond's *Behold! The Bridegroom Cometh*. The Sunday opening hours, from 1 p.m. to 6 p.m. were longer than usual, and the show opened for a few hours in the week as well. With an eye on Barnett, the Society decided to admit the public without their first writing for tickets, and this move was reflected in the increased Sunday numbers – over 2,000 on 28 August, over 1,000 on 4 September and almost 1,000 on 11 September. Four months later, the Society mounted a fortnight's free show in the City of watercolours, prints and photographs from South Kensington plus work by City School of Art students, which again brought in a gratifyingly high attendance at the Sunday afternoon opening. But the less ambitious scale of this exhibition showed that the work involved in organising a loan show for the poor was beyond the capabilities of the Society, and after this it returned to convincing existing galleries to open on Sundays.

In 1887, six years after the first Whitechapel show, the Marquess of Ripon opened a summer exhibition of pictures at the Free Library and Picture Gallery in Camberwell. This Free Library was a descendant of Rossiter's early exhibitions at the South London Free Library and Working Men's College. But whereas the early shows were poorly publicised and badly set up, this one was presented with all the style that had become synonymous with Whitechapel. The eminent lenders and noted artists signalled a new

leaf on the part of Rossiter whose rocky recent years had included property seizures for non-payment of rates and a feud with a *South London Press* journalist. The suspicion that Rossiter had looked to Whitechapel for a lesson in public relations becomes certainty with his opening day speech: 'they would all have noticed that the East-end had lately received a good deal of attention from the rich, but South London had been altogether neglected. This was owing a great deal to the fact that the East-end clergymen had been very active in promoting culture in their parish but the South London clergy had done little or nothing.'[1] Even supposing that Barnett had been influenced by Rossiter's first exhibition in 1879, by 1887 the influence was all on Barnett's side. Barnett seems to have fired Rossiter's ambitions: this show signalled the start of Rossiter's drive to establish the South London Art Gallery, an aim achieved in 1891.

For a few years until it took on a more seriously educational tone in the early 1890s, the People's Palace mounted huge loan exhibitions. The Palace was begun as a teetotal recreational alternative to gin palaces, where East Enders could enjoy themselves in a gently cultural way, and the exhibitions attracted huge audiences – 310,000 for the six-week show in 1890. Similarities with Whitechapel were the starry opening day speakers (the Duchess of Albany opened the first exhibition in 1888), the upper-class and occasionally aristocratic lenders (there were two paintings from the Prince of Wales in 1891), the catalogue, and the late opening hours. Differences were the greater size of the shows (400 pictures in 1889, 650 in 1892), the long exhibiting period of at least four and sometimes six weeks, the inclusion of old as well as modern masters and the entrance charge (Figure 10.1), made possible by the income level of the surrounding area which was slightly higher than that of Whitechapel.

Proof that after ten years the Whitechapel shows had achieved an authoritative status within the field comes from a complaint about the People's Palace catalogue:

> It is carelessly compiled, uninstructive, and full of errors. . . .
> Visitors to the People's Palace are usually neither critical nor
> instructed. They come asking for information, and believe what
> they are told. They are thus misled by reckless negligence, which
> is also the worst possible return that could be made to the
> generous owners who so freely lend their treasures. The clergy
> of neighbouring St Jude's set an example People's Palace
> authorities might well follow.[2]

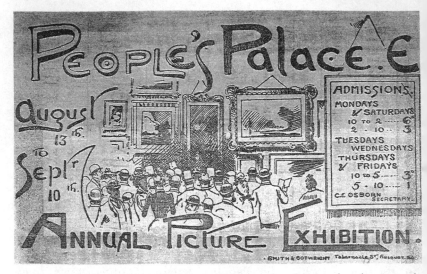

Figure 10.1 Newspaper advertisement listing the charges for the Annual Picture Exhibition of the People's Palace. Archive of Queen Mary College

In 1890 the Guildhall Art Gallery, which owned a collection of paintings connected with the City of London, held the first of a series of loan shows. The Guildhall shows combined the quality of the Royal Academy's old master winter loan exhibitions (fine paintings and royal lenders – kings, queens, tsars and emperors of Britain, Germany, Russia and Belgium) with the social conscience of Whitechapel (no entrance fee, and opening hours till 7 p.m. and Sunday afternoons). The shows were hugely successful, with nearly three million visitors to the fifteen exhibitions between 1890 and 1907 coming to see pictures which in many cases had not previously been publicly shown. New York settlement worker A. C. Bernheim credited the shows to Barnett's example: 'In London, the city corporation, appreciating the importance of the results obtained at Toynbee Hall, has undertaken to give annual exhibitions at the Guildhall (the City Hall).'[3] But despite the efforts to attract the poor, the majority who flocked to the Guildhall were the art lovers and the educated. The Guildhall catered to the motivated and had no wish to preach to or even reach out very far to the unwashed. The catalogue's schoolroom tone turned paintings like J. C. Hook's *Between Tides at Clovelly*, exhibited in 1890, into a visual aid for geography teachers:

> Clovelly is a fishing village built on the face of a cliff, and lies open to the Atlantic. A collier is unlading, and the coals are

carried in panniers by horses up a street too steep for carts. The men are hurrying to unload as great a quantity as possible before the return of the tide. The girl in the foreground is filling a jug with refreshing liquor for the men at work. In the distance is Lundy Island.

Barnett's success gave others the confidence to take part in the picture-exhibiting craze, though they often lacked his religious reasons for doing so. One who did not was a South London minister, the Rev. Thomas Hooper, who in 1890 took Royal Academy paintings as a text for his sermons. The Victorians were interested in the idea of contemporary church art; in 1870, Richard St John Tyrwhitt published an essay considering 'in what manner and how far taste [i.e. good art well regulated] may be of use in Religion, that is to say, good for the individual spirits of Christian people'. He distinguished between instructive church art illustrating biblical episodes and modern paintings 'fitted to convey religious thought to persons capable of it'. As examples of the modern variety he suggested Holman Hunt's *The Light of the World* and *Scapegoat*, Watts's *Jacob and Esau* and *Gates of Death*, Spencer Stanhope's *The Footsteps of the Flock*, Millais's *Parables* woodcuts, Edward Armitage's *Remorse of Judas* and *Herod's Birthday Feast*, and Ary Scheffer's *Christus Consalator*. He recommended that copies of these pictures be distempered by young women on to the interior walls, an operation he believed would 'give heart's content and elevation of spirit to many maidens short of work'.[4]

In 1884 Barnett attracted attention by daringly putting a modern sculpture into St Jude's, an event noted by the local paper:

> A new departure has been made by the Rector of St. Jude's Whitechapel. Having obtained the loan of Mr E. R. Mullins's sculpted group of Isaac and Esau, exhibited at the Royal Academy, he has placed it in his church, where, as we learn, it has not only attracted considerable attention but has been taken as the subject matter for a sermon.[5]

Despite the discussions about art and religion, despite Barnett's sculpture in church, despite the fact that ten years had passed since the first paintings had been moralised at Whitechapel, Hooper's was still a bold move:

> A striking and original discourse was delivered on Sunday evening at the Camberwell Green Congregational church by the Rev. Thomas Hooper, the newly appointed minister of that church, who took for his subject 'Lessons for life, as seen in

some pictures at the Royal Academy'. After stating that Christ appealed to men through both ear-gate and eye-gate, Mr Hooper went on to show that the true painter is essentially a true preacher who interprets both God and man, and is oft-times listened to when the pulpit orator is disregarded. 'I owe more,' said Mr Hooper, 'to John Ruskin than to the greatest of the homilectic teachers;. . . There are several pictures in this year's Academy which . . . embody an idea that originates in life. Such a picture is that of John Bunyan in his cottage home in his young roystering days – the wife reading aloud a good book, the stalwart Bunyan standing at the window longing for the alehouse or the village green, but with the calm tones of his wife's voice ringing in his ears and penetrating to his heart and suggesting the idea which, in later years, absorbed his entire life.

The following year he repeated the performance, affirming that 'if Christ were among us in this age of picture galleries he would exhort the people to look at the painted lessons in pictures'. To exemplify the truth that no human life is complete without another, Hooper pointed to Alma Tadema's *Earthly Paradise* and Marcus Stone's *Love at First Sight*. In his 'struggle for existence' category, he cited Herkomer's *On Strike* (Figure 4.2), making 'some apposite remarks with regard to the strained relations existing between capital and labour'. Calthrop's *The Song of the Shirt* inspired a homily on the evils of sweated labour, and Fildes's *The Doctor* (Figure 10.2) gave rise to, 'As long as we have a picture such as this to set forth the noble heroism of the medical man, we shall have something to remind us of the devotion of the Lord Christ.'[6]

While the role of elevation which had developed out of the 1836 Commission was becoming clearer by the year, its sister role of education began to blur by opening itself to fine art. By the 1880s, opposition to the copying in lead pencil fostered by the Science and Art Department's examinations took the form of pleas for colour, for paint and for freer drawings. Earlier goals of the production of educated consumers to support better-designed goods and designers to compete with those abroad were replaced by vaguer notions of increasing the students' cultural knowledge and their capacity for enjoyment. In 1884, readers of the *Magazine of Art* learned that 'it is only in comparatively recent years that loan collections of fine art have come to be regarded not merely as an additional attraction to industrial exhibitions but as absolutely necessary to success'. In the 1880s, Milton Hall in Battersea, a church-sponsored centre

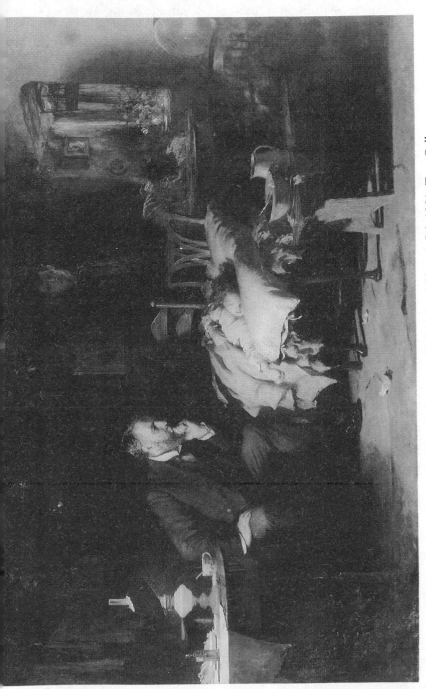

Figure 10.2 Luke Fildes, *The Doctor*, oil, 164.5 × 239 cms, RA 1891, Tate Gallery

offering recreation and mental elevation to its working-class visitors, mounted a Free Fine Art Exhibition based on Barnett's example, at which paintings by the eminent artists Seymour Lucas and Tissot were shown alongside objects by local artisans, which included a display of cash registers to encourage donations to cover the cost. An Industrial Art Exhibition opened in Bethnal Green in 1886 by Princess Louise and the Marquess of Lorne displayed paintings as well as locally produced artificial flowers, weaving and glass. These shows mark the meeting of the educational and elevating powers of art. Even though the well-heeled and high-born had been lending paintings to boost the South Kensington circulating collection since the 1860s, it is unlikely that the local shows would have taken so enthusiastically to exhibiting paintings without Barnett's more recent and spectacular example.

11

Clones

In 1888, readers of Mrs Humphrey Ward's immensely popular novel *Robert Elsmere* were introduced to the latest fashion in good works. In Chapter 39, the aristocrat Hugh Flaxman rides to the East End:

> Most of the way he was deep in talk with Lady Charlotte as to a certain loan exhibition in the East End, to which he and a good many of his friends were sending pictures. He was talking now as a man of possessions and influence. She saw a glimpse of him as he was in his public aspect, and the kindness, the disinterestedness, the quiet sense and the humour of his talk insensibly affected her as she sat listening.

Loan exhibitions à la Whitechapel became a small fashion in the 1890s, and upper-class interest in them had much to do with this. Going into the slums to teach baby care to new mothers exposed you to the risk of infection, and ladling broth in soup kitchens brought poverty and bad table manners unpleasantly close, but lending a painting or two to an East End exhibition was a clean and fashionable way of doing good which recommended itself to many who would normally flinch from facing the poor. By 1890 Barnett was able to say with satisfaction that the exhibitions, once mocked, were now imitated.

The main channel for Barnett's influence was the settlement houses. The pool of concerned workers on which they could call, their aim of developing oases of culture in poor urban areas and the fact that the originator of the exhibitions had masterminded the birth of Toynbee Hall, made them the logical locations for the continuation of the Whitechapel example.

Because picture shows in poor areas were such high-profile events, observers tended to think there were more exhibitions than

was actually the case. By 1914, Dr Werner Picht noted that a good number of settlements organised shows,[1] but in fact it only seemed that way since any settlement putting on an exhibition automatically attracted attention. Not everyone in the movement shared the Barnetts' particular set of cultural and religious beliefs, or if they shared them, they carried them out in different ways. Some settlements were more interested in improving the welfare of the poor in their catchment areas than in educating them. Others believed in the healthy mind in the healthy body philosophy, and the word art cannot be found among the thousands devoted to sporting activities in their records. Few were as fashionable as Whitechapel, which from the start had attracted the rich, famous and educated to play a part in its programme, and most lacked the time, the funds, the workers and the contacts to put on shows.

Nonetheless, a few settlements made a committment to an annual exhibition with the aim, as one put it, of 'alienating the South Londoners from their squalid and sordid surroundings'.[2] First off the mark was the Woman's University Settlement which began exhibitions in 1890. In 1892 it amalgamated with Morley Memorial College and Borough Polytechnic, and under the name of the Southwark and Lambeth Free Loan Exhibition the shows continued till 1913. Next were the shows put on by the Mansfield House Settlement in East Ham from 1895 to 1903. Third were the Bermondsey Settlement exhibitions from 1896 until 1913, with the exception of Jubilee year in 1897.

The Whitechapel pattern was followed closely. All three opened in the spring, Mansfield House's earlier opening enormously irritating Whitechapel, 'Easter being the only time possible for us.'[3] All stayed open till late in the evening, all had catalogues, all invited important speakers to make the opening day address, all showed pictures which had been lent to them, all acknowledged the Whitechapel source. At the opening of the first Mansfield House exhibition, the warden said that 'it was of the utmost importance that exhibitions of this kind should be held, not only in Canning Town, but everywhere in East London. They had done well to follow the example of Toynbee Hall in this respect.'[4] There were a few differences, but they did not affect the pattern. Mansfield House exhibitions were financed by the local Council as the warden was a member and talked them into it, and its shows were moveable: the first two weeks in Canning Town, the next two in the town hall in the north of the borough. The mid-show move meant that two opening day speakers had to be found each year

and two catalogues had to be printed since some pictures tended to be withdrawn and others added at moving time.

The slavish following of the Whitechapel pattern is not surprising considering that its success was their inspiration. The same illustrious names turn up to open all the shows, the clergy appearing more frequently as the novelty and glamour wore off in the early years of the twentieth century. The Marquess of Lorne opened the Southwark Art Exhibition in 1891 and the Bermondsey Settlement Loan Exhibition in 1896. Holman Hunt spoke at Whitechapel in 1888 and at Bermondsey in 1896. The Archbishop of Canterbury spoke at Whitechapel in 1892 and at the Southwark and Lambeth show in 1893. Hubert Herkomer, who opened Whitechapel in 1889, spoke at both Whitechapel and Southwark and Lambeth in 1894. The Duchess of Albany, who had declared the Whitechapel exhibition open 'in clear and ringing tones' in 1890, was only stopped by ill health from repeating the performance at the Southwark and Lambeth show in 1893. It is clear that a pool of willing speakers existed who were sympathetic to the cause of art for the poor, and the fact that so many were eminent or titled reveals the establishment's connection with art and its concern about the problem of poor.

The sentiments they uttered in support of the shows were the familiar Whitechapel ones. The Rev. A. Boyd Carpenter, rector of St George's, Bloomsbury, said that 'those for whom the Exhibition had been primarily intended were the hard-working poor, into whose lives little joy or light seemed to come'. Canon Holland said that art was given to widen one's range of understanding. The Rev. Carpenter was glad the exhibition was open on Sunday: 'He could not see why works of art and beauty should not be seen on that day; it was unfair to art, man, and religion.' Canon Holland agreed, but thought people 'ought to go to church first on Sundays and visit the exhibition afterwards. They could not imagine that God's gifts were set against each other.'[5]

Money for the shows, which cost between £100 and £200 was raised in the familiar Whitechapel manner with boxes placed in the rooms for voluntary contributions (never very much – 769 coins amounting to £4.13s.11d. were collected to offset against the £160 cost of the 1890 Southwark and Lambeth show), from donations from the sympathetic and well-heeled (quite a lot) and from the sale of catalogues which were priced high on opening day and low thereafter (not much). The Bermondsey Settlement's annual report for 1898 lists the most expensive items as collecting and delivering the pictures, £32.14s.6d., insurance at £28.12s.6d.

and printing at £24.19s.0d. Hanging the pictures cost £15.3s.0d. and fixing barriers was £14.10s.4d. As at Whitechapel, pleas on opening day for sympathisers to meet the deficit were a regular occurrence.

To get the visitors' interest, the organisers adopted the Whitechapel practice of voluntary watchers to control the crowds. To keep it, the watchers were expected to talk about the pictures. Voting for favourite pictures was encouraged, and, as at Whitechapel, narrative pictures were the most popular. In first place at the 1890 Southwark and Lambeth exhibition was Edwin Long's *Rose of England*, second was Landseer's *Helvellyn* (in the words of the local paper 'a picture of the faithful dog watching in distress by his dead master who had fallen from the top of the rock), and third *The Secret Joke*, 'a spirited picture with vivid minute detail, of two cavaliers whispering across the table'. In 1893 at Southwark and Lambeth, Stanhope Forbes's *Health of the Bride* came first and a portrait of the Prince of Wales second. Children were encouraged to vote and though their ballots were kept separate, their choices always coincided in one or two cases with those of the adults.

The catalogues followed the Whitechapel pattern. Mansfield House produced the most elaborate one, with portraits of artists and a list of art books available for reference in West Ham public libraries, hardly surprising since it was the libraries committee which was paying. As at Whitechapel the catalogues were decorated with quotations connected with art. Charles Kingsley, Browning, Emerson, Pater, Plato, Ruskin and William Morris were favourite sources. The first Mansfield House Settlement catalogue carried Ruskin's 'life without industry is guilt and industry without art is brutality' on the cover, and printed Watts's 'What Should a Picture Say?' as a preface. It was all very serious, like opening the Bible or a book of poetry.

The real difference between Whitechapel and the offspring exhibitions was not in kind but in quality. The new shows tended to be smaller, the paintings less spectacular and the visitors fewer. Loan shows did not automatically command huge audiences. At the opening of the 1896 Bermondsey show, the Bishop of Ripon mentioned that the promoters of similar exhibitions had been disheartened by poor attendance and want of appreciation.

Most impressive in terms of visitor numbers were the Mansfield House exhibitions, which attracted 100,000 visitors to the first four-week show, and even when attendances dropped in 1900, still topped 80,000. The attendance figures at the other two shows never approached this level and as the years passed the numbers

fell off. The Southwark and Lambeth shows grew from 18,000 in 1890 and 1891 to 32,000 in 1894 before dropping to less than 10,000 for the three final shows before the outbreak of the First World War. Bermondsey had 12,000 visitors for its first show ('mostly of the working classes' according to the annual report), 10,000 for the second in 1898 (inclement weather was the reason given), 11,000 in 1903 and 8,000 thereafter, dropping to 7,000 in 1913.

None of the shows exhibited as many paintings as Whitechapel. Mansfield House made the biggest splash with an average of between 200 and 250, rising to 292 in 1897, probably because Bermondsey's decision to drop its show that year released some lenders. Things sagged after 1900 with 156 paintings in 1901, 175 in 1902 and a panic in 1903 when they had trouble getting enough pictures. The other shows mustered between 100 and 200 pictures, depending on the energy of the organisers.

Some fine pictures were exhibited but standards declined as the years passed. Eminent painters like Tuke, Napier Hemy, Wyllie and Frank Goodall were displayed at the first Mansfield House exhibition, but the last show was made up of a much smaller collection by minor artists. There was a higher proportion of older pictures, which were excluded by Whitechapel's aim of showing the best in modern art, and a higher proportion of paintings 'after' artists. By 1912, Bermondsey was displaying work by the settlement's photography class, a practice far removed from Whitechapel's disdain of amateur art.

The organisers must have used the Whitechapel catalogues as a source of willing lenders, for many of the names are familiar. The Earl of Carlisle, the Duke of Westminster, Lord Battersea and Queen Victoria all sent pictures to early shows, although they stopped doing so as the years went by and the exhibitions lowered their standards and lost their novelty.

The catalogue, which Barnett considered his greatest educational tool, was copied, but whereas Barnett knew precisely what message he was trying to convey, the composers of the newer catalogues were not so sure. Factual information was stressed – explanation of Greek myths, for example, or information on the lives of the artists. Southwark and Lambeth described Mrs H. M. Stanley's *Drink* in 1899 as 'The husband mad from drink, after beating his wife and breaking the furniture, stumbles out of the room, leaving his wife desperate, seated on an overturned chair, her little son vainly trying to comfort her'. Barnett would never have left it at that. Paradoxically, the decision to limit

themselves to description and stand back from the minefield of morality resulted in their talking down to the visitors. Barnett may have been eccentric in advising his visitors to seek motherhood in the eyes of a cow, but his attempt to appeal to the spectators' finer feelings was flattering in that he truly believed they had finer feelings to touch. Most of the settlement organisers were religious and thought much as Barnett thought, but they lacked his mission to convert to Christianity through art. In 1890, the Lambeth and Southwark catalogue was scathingly criticised by a local journalist:

> Many of the 'notes' are adapted only to the most childish intellect. Under some pictures of the 'impressionist' school it may be found necessary to write 'this is a cow' or 'this is a shop'; but surely with regard to pictures which tell their own story it is unnecessary to append such notes as these: 'The Runaway Horse (T. Faed, RA). Note – a horse has broken the traces, and is rushing through the farmyard; danger to the children. Let us hope they will get out of the way.' 'A Concert (J. Tissot). Note – a party, in a handsome drawing room, listen while a lady plays the violin.' It is a poor compliment to the painter to suggest that even the children who visit the picture gallery could not find out these facts for themselves. Here are a few more examples of catalogue making for the people: 'The Tea Garden' (E. G. Beach). Note – everything seems to be ready in the garden except the tea. . . . Let us hope the teapots and the plates of bread and butter will appear presently.[6]

The compilers of the Whitechapel catalogue, informed with a belief in the message they were imparting through art, never sank to so patronising a level.

As the years passed, and the original impetus failed, a didactic tone emerged as if the writers were using the pictures to improve the visitors' manners: 'I wish people who ramble through the woods would be contented with their share of wild flowers. I know a wood where these stately crimson spikes would stand six or seven feet high by the thousand, but hardly any one day reach this height,' querously ran the Southwark and Lambeth note to *Foxgloves* in 1905. Over the years, the religious message was replaced by a view of the picture shows as an educational aid:

> Some say our administrators will try to make London the fair city it might be, but the motive power which will demand such an improvement can only come by patiently educating the tastes of growing numbers of our citizens so to perceive and enjoy

what is beautiful, they will combine against squalid and sordid surroundings . . . a picture show is both a present pleasure, rare indeed, and a means of education, which will gradually have great practical results.[7]

One development which affected the style and tone of the shows was the increasing number of child visitors. After the Education Department recognised the time spent in galleries as time spent in school, school visits gave some shows a motive for continuing. In 1912, Bermondsey's opening was attended chiefly by London County Council teachers, and in 1913 a good many of the 7,000 visitors who came to view the 170 pictures were children: 'relays of school boys and girls were to be seen examining the works of art, making notes and showing a genuine and intelligent interest in the pictures.'[8] Southwark and Lambeth held children's concerts and aimed captions at the younger visitors: 'Many mothers would be glad to have so useful a boy. It shows the good disposition of the lad that he does not think it any hardship, but rather a pleasure, to polish up the pots and pans on his Saturday holiday, so that all may look clean and bright for Sunday,' ran the comment to *Helping Mother*. Only sixteen of Bermondsey's 158 pictures were commented on in 1912, which suggests that this means of education was no longer pursued with enthusiasm.

Since the settlement house movement was a major nineteenth-century British export, it is no surprise to find loan exhibitions opening on the other side of the Atlantic. In Chicago, the famous Hull House mounted exhibitions between 1891 and 1895. Its founder, Jane Addams, had visited Toynbee Hall and Ellen Gates Starr, who was responsible for artistic matters, was heavily influenced by English ideas about art and the poor. She admired the writings of William Morris, had studied bookbinding with Cobden Sanderson and was a disciple of T. C. Horsfall's art for schools initiative, which she tried to emulate in her own art for schools loan collection. Under her direction, much attention was paid to the role of art in 'bringing meaning and purpose into the drab lives of their immigrant neighbours'.[9]

The first Hull House exhibition held in June and July 1891 was opened by Samuel and Henrietta, who were on a world tour at the time. Barnett's address was reported in the Chicago press:

Pictures, like parables, speak to everyone and are valuable not so much in what they say as what they suggest. . . . In a photograph we see something as it is – in a picture we see it as it appears to a man of genius. A common man sees a common

thing through the eyes of an uncommon mind. (Applause)

The speaker then gave many interesting descriptions of interviews with the London poor. He told of incidents where the fallen and neglected were recalled to thought by the works of great masters where possibly words of preachers would have failed.

He told of the poor dock labourers of London who had their daily toil lightened by seeing what an artistic eye could depict from the beauties of the Thames.

'A great pictorial work enlarges and elevates the mind,' he said. 'No man has any more right to shut up a great work of art than he has to imprison a preacher. . . . Whatever your material prosperity may be it is only from the elevation and cultivation of mind that your true happiness can come'.[10]

The exhibitions were smaller than those of St Jude's, although several were held each year and the quality was high. The first had only twenty pictures, one of which was Watts's *Time Death and Judgement*. A show held from 29 November to 14 December 1891 included a Rembrandt, Van Goyen, Ruysdael, Teniers, Daubigny and Strudwick's *Isabella* among its twenty-one pictures. The largest number of exhibits was 110 for a show of engravings and etchings in October 1891. Interest was encouraged by voting, late opening and the decision to keep the shows to a manageable size; the catalogue limited itself to title, artist and lender with an occasional informative passage of the 'darkness of the stiff evergreens contrasts with the warm purplish tint of the trees' type. Within a few years, the exhibitions faded away, and it became Hull House policy to urge people to attend the Art Institute to which the catalogue had been directing people for some time, listing the free days.

The Whitechapel shows were copied for a short time at the University Settlement in New York on the suggestion of A. C. Bernheim. The first show in 1892 stayed open for six weeks and 36,000 people came to see the oil paintings, sketches and watercolours. The month-long show in 1895 drew nearly 106,000 visitors to view 123 paintings, a total which rewarded the organisers' decision to distribute free tickets around the neighbourhood. Paintings included works by Daubigny, Corot, Gerôme, Israels, Homer, Remington, Monet and Reynolds. Voting was encouraged and because, as at Whitechapel, the visitors thought a lottery was connected with the voting, the organisers printed on each paper, 'this ballot does not secure for any person the chance

of getting one of the pictures. You can win nothing by filling out this blank. It is only a vote by which the people declare which pictures exhibited are their favourites.' Sharing Barnett's desire to get the visitors to look at the landscapes, the organisers printed 'nature picture' on the ballot papers since they did not think anyone would understand the word landscape. 'This proved very misleading – any picture with a "natural" subject of the genre class being regarded as a "nature picture" – and consequently receiving the vote that it had been intended to reserve for a landscape.'[11]

One of the things that stands out about the New York exhibitions is the absence of Whitechapel gentility. Labour problems, immigrants and the shortcomings of national museums were seen as facts to be faced when putting on loan exhibitions in New York. They were factors of Whitechapel life as well, but not a mutter can be heard on these matters from Barnett and Co., who were working hand in hand with the establishment to achieve their aims. The only headaches admitted by Barnett came from the poor's resistance to his message and these were private worries kept to letters to his brother. In 1897 when there were over eighty pictures by Watts at Whitechapel he fretted that 'Watts is above the people – or rather he makes demands on thought which people are too tired or too busy to give'. In 1900 he talked to the Holman Hunts at a private view at the Royal Academy of 'the way people patch their minds and refuse to think or study'.[12]

Although he spent years campaigning for a permanent museum for Whitechapel, the only museum he ever criticised was Bethnal Green, calling it a 'somewhat desolate place', but then everyone criticised it in the 1880s. It had no catalogue and no lectures and Walter Besant called it a 'complete and ignominious failure . . . it was especially designed to create and develop a knowledge of art and it has not done so. . . . It is, in fact, a dumb and silent gallery.'[13] Bernheim in New York wanted local exhibitions, but he was not politic about it, asking why the city government could not contribute money to the Metropolitan Museum of Art to enable it to provide an exhibition for at least part of the year in the poorest area of the city.

Barnett believed in his catalogue, but he neither criticised others nor recommended his own. In New York the catalogues, which were based on the *Pall Mall Gazette*'s National Gallery guide, were offered with confidence and criticism of their Metropolitan Museum counterpart:

The catalogue, such as it is, will no doubt be preferred by 'the

common people' to those barren catalogues of names in art
academies and art museums. . . . Such a catalogue, full of
historical, biographical and art notes with reproductions of the
best pictures, would increase the benefits of the museum a
thousand fold to the multitude of people who go there on
Sunday afternoons.[14]

Barnett chose to deal with hostility between the classes by
preaching his philosophy of the Seamless Society through the
paintings. The New York organisers accepted it as something to be
faced and fought. Recalled a helper:

A prominent Socialist of undoubted sincerity and deserved
repute among the Russian Jewish section bluntly refused his co-
operation. 'The robbed and the robbers cannot sincerely
fraternize,' he said, 'especially when the robber comes asking the
robbed to accept as a favour a few crumbs from the feast which
is the creation of the latter. . . . The labour movement is a class
movement and nothing should be done to weaken the class
spirit.'

Tact won the day. The writer suggested that the taste of the masses
should be educated for a better system when it comes:

or the time be ripe for forcing it. . . . The result was the most
bitter and radical of the Jewish socialists became our firmest
friends, and worked incessantly as 'runners', guiding droves of
people to the exhibition evening after evening – and the right
kind of people, too – by the 'laws of natural selection'.[15]

Barnett's silence on the subject of the Jews is odd. Whitechapel
was a primary place of settlement after 1870 for Jews fleeing
persecution in Eastern Europe. Newspaper illustrations prove that
they went to the exhibitions and the fact is backed up by the
attendance of Jewish dignitaries at Whitechapel opening ceremonies
and the Chief Rabbi's statement in 1895 that Jews had been
attending the shows for years. But though they went, Barnett never
says a word about them. It might have been a kind of tactful
nervousness, since any Anglican clergyman suspected of trying to
convert the Jews was entering a minefield, but it is as likely that he
was pretending the Jews were not there. Their foreign habits were
offputting to those who gathered at Toynbee Hall to teach, to do
good, or to better themselves, and their religion precluded them
from receiving the Christian message which lay behind the
exhibitions. In New York where the aim was to teach not preach,

the presence of Jewish immigrants was accepted to the degree that the ballot slips and catalogue were printed in Hebrew as well as English.

Although the settlement shows began with the Whitechapel dazzle, most lost their lustre as the years passed. Firstly, Barnett knew precisely why he was bringing the best in contemporary art to the poor. His imitators lacked his vision and conviction, or they were willing to accept second best, or, as the catalogue notes make clear, they lacked confidence in the direction they had taken. Secondly, organisation proved a problem. The settlements found that getting collections of pictures together took tremendous dedication, and though the good intentions were there, the contacts and time were not. It is no surprise that in 1901 when the Southwark and Lambeth picture committee secretary died, there was no show, or that Mansfield House attendance dropped after the warden resigned. Thirdly, history was against them. In the 1880s bringing art to the poor was in the air and Barnett was the right man in the right place with the right zeal. By the next decade, the situation was starting to change. The state's acceptance of its responsibility for education, the growing numbers of the poor who were convinced that education offered a way out of poverty, the growth of institutional belief that learning should be offered to all, shown, for example, in the development of university extension courses, the mushrooming of museums inspired in many cases by amateur exhibitions and activity, meant that the loan show organisers could gracefully and no doubt gratefully hand over the job to professionals. Civilising the rough through religion had been the impetus, civilising the rough through education was the legacy.

A picture of the poor

All the accounts of the reactions of the poor to the exhibitions have been filtered through upper-class eyes. The poor themselves have left no reports. In one respect this is unsatisfactory because it means that the descriptions of the poor's reactions are in reality interpretations made by outsiders. The poor, in fact, become an exhibit for the rich: 'But, after all, what interests the West-end visitor in this show is not the pictures – he has probably seen all of them at different exhibitions in the West – but the people and the People's Palace.'[1] But in another respect, these reports by the educated and upper classes are a revelation of contemporary attitudes towards the poor. On the whole, the writers were pleasantly surprised by the looks of the visitors, to the Whitechapel show in this instance:

> What chiefly surprises most visitors is probably the *respectability* of their more easterly brethren. Here and there are to be seen, indeed, the faces of the 'aimless', helpless, hopeless, ne'er-do-wells, whose existence is misery to themselves and despair to the social reformer. But on the whole, the aspect of the crowd is pre-eminently cheering. The men look sober and industrious, the women neat and modest, and here and there are to be found strikingly fine types.[2]

Barnett's dream of reaching the poorest through his pictures was not to become reality. Though in the early 1880s Whitechapel attracted a proportion of the very poor, as the exhibitions continued and were imitated, greater numbers of the middling poor attended, in part because Barnett's experiment in spiritualising the poor coincided with the desire for education of the upwardly mobile. This trend worried the organisers. At the People's Palace,

tickets were distributed to the local clergy in an attempt to reach some of the really disadvantaged:

> Every evening some 1,500 had free entrance, and of these 1,400 were chronic sufferers from the most abject poverty. In fact more poor people have visited the Palace during the past three weeks than in any previous three months. Even the children came. Numbers of ragged youngsters from the poorest slums trooped in to such an extent that it was on some evenings necessary to place a limit on the inflow. . . . A little group one night was composed of a little girl, to whose skirts hung on two young members of the same family, and in whose arms there was a baby. Children-like, they wanted to see the pictures. The crowded state of the hall precluded any possibility of gratification.
>
> There they wistfully stood, baffled in their desire at the very door. Mr. Osborn, pitying their forlorn condition, and being unable to take them in, did the next best thing – he consoled them with a penny, and the suddenly enriched wee folk scampered off in search of the toothsome, but indigestible bun.[3]

That the Whitechapel visitors were not the true untouchables is obvious from the fact that the catalogue explanations were seen as the main link between people and paintings. Henrietta Barnett wrote that '"No, ma'am, thank you, but I ain't brought my spectacles" was often the reply when one offered a catalogue, a conventional formula for saying, "I can't read"'.[4] But this single reference to illiteracy is far outnumbered by anecdotes about catalogue readers, and the catalogue sales confirm the high proportion of literate visitors. Even though the classes had different standards of cleanliness, illustrations show visitors free of rags and tatters, and Mrs Barnett's assertions that artisans made up the bulk of the visitors suggests that newspaper artists were relieved of their customary duty to clean up the poor for their publications.

The People's Palace exhibitions attracted a slightly more respectable class of people than Whitechapel, better dressed at least. This was due to Bethnal Green's slightly higher position on the income scale and the fact that the Palace exhibitions started later in the century as conditions were improving.

> The very respectability of many of the visitors is apt to be a drawback. A man comes in corduroys and finds an empty seat beside a person much better attired. Shortly after a smart young

mechanic in his Sunday best flanks him on the other side, and the immediate contiguity of people so palpably dressing for the occasion instinctively suggests to the man in the corduroys that his working clothes suffer by the contrast. For a moment he shuffles uneasily in his seat, and then makes a desperate exit.[5]

Confirmation that the visitors were not the poorest comes from Booth's estimate that a little over a half of the East End population was made up of the artisan class, as well as from the novelist Arthur Morrison who in *A Child of the Jago* of 1896, a disturbing contemporary account of the destructive power of the East End environment on the young, states that it was the higher grades of the poor who accounted for most of the visitors to art exhibitions. Since Morrison had worked in the administration of the People's Palace for several months before its opening in May 1887, since for nine months in 1889 he was sub-editor on the Palace *Journal*, and since the novel's West End Mission and Pansophical Institute was based on that institution, his comments should be taken seriously:

> The triumphs of the East End Elevation Mission and
> Pansophical Institute were known and appreciated far from East
> London, by people who knew less of that part than of Asia
> Minor. Indeed, they were chiefly appreciated by these. There
> were kept, perpetually on tap for the aspiring East Ender, the
> Higher Life, the Greater Thought, and the Wider Humanity:
> with other radiant abstractions, mostly in the comparative
> degree, specific all for the manufacture of the Superior Person.
> There were many lectures given on still more subjects. Pictures
> were borrowed and shown, with revelations to the Uninformed
> of the morals ingeniously concealed by the painters. And there
> were classes and clubs, and newspapers, and games of draughts,
> and musical evenings, and a brass band, whereby the life of the
> Hopeless Poor might be coloured, and the misery of the
> submerged alleviated. The wretches who crowded to these
> benefits were tradesmen's sons, small shopkeepers and their
> families, and neat clerks, with here and there a smart young
> artisan of one of the especially respectable trades.[6]

As well as commenting on what the poor looked like, there are a number of reports describing how the poor behaved — remarkably well, it seems: 'In short, if a West-Ender wishes to improve his opinion of the "lower classes" let him try a "watch" at the eleventh annual picture exhibition at St Jude's Schools, Whitechapel.'[7] Although Booth described Whitechapel as possessing 'this excite-

ment of life which can accept murder as a dramatic incident, and drunkenness as the buffoonery of the stage', few incidents of drunken behaviour are reported.[8] Henrietta's sole reference comes in her list of factors to be taken into account in hanging the exhibition:

> To those we had to add the knowledge that people crowded and lingered round the pictures with a story and that the floors were weak – and therefore only one popular canvas could be placed on each wall – and that the means of egress and exit were small, visitors sometimes drunken, and panic easily aroused in crowds.[9]

Despite the occasional suggestions of working-class degradation and bad behaviour, the reports represent the visitors as remarkably docile. Their mentors chronicled their reactions, allowing themselves to be moved by their sensitivity and amused by their ignorance – reading aloud 'Dog's Palace' for Doge's Palace was one rib-tickling example. Several observers noted the poor's serious attitude, remarking that while the West Enders went to their galleries to look at each other, the East Enders went to look at the paintings. Others unfavourably compared the sophisticated art criticism engaged in by the West Enders with the poor's innocent fascination with the story. The following passage shows how the Victorian artists' stress on content made this picture-reading by the poor a possibility:

> Not art connoisseurs, indeed, are these folk, but the pleasure they derive is probably deeper, and certainly fresher – whether it is the pleasure of the workman engrossed by the quarry scene, reminding him, perhaps, of some incident in his early life before he was dragged into the maelstrom of London; or of the young woman who stands entranced, like Wordsworth's town girl with the song of the caged lark, by the picture of the great red sunset over the flat lands of Eastern England. These people look at pictures to get more life out of them, and who shall blame them? The artist lends his mind out to them, and they greedily accept the loan. 'Poor thing, how tired she is! – Look, look, mother! There's a horrid snake eating a woman!' – or, wonderingly at some fat Madonna or Titian, 'I don't think she was like that!' Nor was she! And it is better and truer art criticism to say so than yards of talk of the richness of her colouring.[10]

All the reporters were on the look-out for art in action, civilising, refining and working miracles on the visitors:

> There is one poor soul whose face speaks eloquently of intense weariness of mind and body, and very straitened circumstances. She has a small basket on her arm, and passes slowly round with a look of perpetual sadness. She is not interested in fashionable portraits, but stops longest at Giorgione's *The Dead Saviour*. She asks the bystander with a catalogue what the subject is and this having been gently explained to her, she bestows one more look of intensely-quickened interest, and then, with deepened sadness, passes on, and sinks into a seat under the shadow of the gallery, where she may be left to the reflection to which the mute canvas had given rise.[11]

Only rose-coloured spectacles could have transformed the woman's symptoms of clinical depression into the subtle appreciation of religious subject matter which the reporter was intent on finding. There is no doubt that the writers saw what they searched for, and what they searched for was proof that the exhibitions 'worked', that is, had the desired effect on the people who visited them. The tone of satisfaction with the poor for behaving so well and responding so appreciatively is due to the fact that such behaviour confirmed their betters' belief that art was an effective conduit for civilising.

Proof that art worked could could also be drawn from the results of the favourite-picture voting. 'Last year the choice fell on Holman Hunt's *Triumph of the Innocents*, F. D. Millet's *Love-Letter*, Burton Barber's *Trust* and Walter Crane's *Bridge of Life*,' wrote Barnett as proof that his spiritual message was getting across. 'From the choice the general conclusion may be drawn that pictures are valued as expressions of thought.'[12] Since Barnett believed in the Ruskinian equation that the worth of a painting equalled the worth of its idea, the conclusion is no surprise. But the fact that *Triumph of the Innocents* was screened off from the rest of the collection raises questions as to whether it was pictures as expressions of thought which appealed or pictures hung in eye-catching positions. While privately admitting that the visitors did not always share his vision, confessing in a letter to his brother that the Watts paintings led him to dread a rebellion 'as sermon after sermon rolls off successive canvases',[13] in their published writings Barnett claimed that the visitors loved the allegorical works once they had been explained: 'Mr Richmond's *Sleep and Death*, as well as Mr Watts' *Time Death and Judgement*, both ideal rather than

historical or domestic pictures, were greatly enjoyed, and this by a class of people whose external lives are drearily barren of ideals.'

In reality, it was the historical or domestic pictures which were most popular, but even as Mrs Barnett reveals this she cannot resist adding that when aided by catalogue or talk 'even these' were overtaken in popularity by the pictures embodying the highest spiritual truths. The Barnetts' desperate desire to find the best in their visitors led them to consider even their silence as positive: 'Most frequently, though, a picture will draw forth no expression – for with the unlettered all expression is difficult and we know how, in the presence of death, of a grand sunset, or of anything deeply moving, silence seems most fitting.'[14]

The need to believe that pictures acted as secular sermons led to its own special set of myths of visitor reaction. The organiser of a Guildhall exhibition recalled the effect of Thomas Faed's *Worn Out* on two factory girls:

> It showed a carpenter tending his sick child through a restless night. Dawn finds him worn out with watching and both he and the child have sunk into sleep. Two factory girls were looking intently at the picture one day: as I was passing them I paused for a moment. One of them was reading aloud the descriptive note in the catalogue, at the conclusion of which they both resumed their silent gaze at the picture. Presently one of them said, 'It ain't always the clothes that show the heart, is it?' I should have liked Faed to have known of this.[15]

This description is strikingly close to an incident described by Mrs Barnett.

> Mr. Schmalz's picture of *For Ever* had one evening been beautifully explained, the room being crowded by some of the humblest people, who received the explanation with interest but in silence. The picture represented a dying girl to whom her lover had been playing his lute, until, dropping it, he seemed to be telling her in impassioned words that this love is stronger than death, and that, in spite of the grave and separation, he will love her *for ever*. I was standing outside the Exhibition in the half-darkness, when two girls, hatless, with one shawl between them thrown round their shoulders, came out. They might not be living the worst life but if not they were low down enough to be familiar with it, and to see in that the only relation between men and women. The idea of love lasting beyond this life, making eternity real, a spiritual bond between man and woman,

had not occurred to them until the picture with the simple story was shown them. 'Real beautiful, ain't it all?' said one. 'Ay, fine, but that *For Ever*, I did take on with that,' was the answer. Could anything be more touching? What work is there nobler than that of the artist, who, by his art, shows the degraded the lesson that Christ himself lived to teach?[16]

Despite the transformation of the goal from material to spiritual improvement, the activity of the underprivileged being aided by the privileged had been retained. These accounts of good by pictures are a version of philanthropy in which paintings have replaced pounds.

The socialist challenge

In the 1880s the socialists threw down a challenge to Barnett's use of art for the poor. William Morris's theory that art and society were intimately related grew out of the same despair about the working classes which had galvanised Barnett. But whereas Barnett wanted to reveal the messages of paintings to the poor in an attempt to spiritualise them, Morris envisioned a utopia of happy craftworkers. Barnett wanted the lower classes to look, Morris wanted them to make. While Barnett wanted pictures to polish up the poor while keeping them in their place, Morris demanded a new society in which contentment would come from lifestyle. His dream bypassed the patronising do-gooding element in Barnett's work.

Although the Morris version of how art could improve the poor has most appeal to us today, in the 1880s it was seen as a minority view and a utopian one, and it was Barnett and his supporters who were considered to be realistically addressing the problem. Though it might seem odd that Barnett was so little touched by Morris's socialist ideas, it would have been odder if he had been. At the end of the 1870s when the reformers were organising their ideas about taking pictures to the poor, Morris was not adding anything to what Ruskin had already said, and when Morris finally formulated his socialist theories in 1883, pictures for the poor was launched and Morris's beliefs were at odds with the movement's goals.

William Morris as socialist thinker on art came into his own in the 1880s. Following his false start as a painter after he and fellow Cambridge student Edward Burne-Jones presented themselves to the Pre-Raphaelite artist Dante Gabriel Rossetti in an act of youthful homage, he became increasingly involved with the decorative arts. Two authors affected him deeply. In the mid-

1850s he read Ruskin's 'The Nature of Gothic', and from the end of the 1850s to the end of the 1870s, all his activities – working in an architect's office, commissioning furniture for his new home, starting the decorative arts firm Morris, Marshall, Faulkner and Co. in 1861, founding the Society for the Preservation of Ancient Buildings – were imbued with his belief that the practice of the crafts contributed to a healthy society. In 1883 he read some Karl Marx. Henceforth his acceptance of Ruskin's belief that good societies and good art were linked was broadened into the socialist belief that only by overthrowing capitalism could a structure arise to allow a society of workers fulfilled through the practice of the arts and crafts.

Morris's career in the decorative arts gave his own personal twist to marxism, in which art was given the roles of analysing the failings of capitalism and of realising the dream to come. In an analysis which has retained its persuasive force over a hundred years, he stated that society's unhealthy state was due to the unnatural division of labour between the fine and the decorative arts which had developed since the sixteenth century, a division mirrored in the social status of the producers of the two kinds of art, 'those who follow the intellectual arts being all professional men and gentlemen by virtue of their calling, while those who follow the Decorative are workmen earning weekly wages, not gentlemen in short'.[1]

He had several solutions for this state of affairs. He wanted to abolish the situation whereby art was limited to easel paintings produced by specialists whose self-conscious aim of creating beauty distinguished them from the majority of workmen and which left the mass of the population untouched. In place of the esoteric activity of easel painting, produced and appreciated by an educated minority, he proposed an art, including easel paintings if needed, produced by craftsmen anxious to turn out a creditable piece of work, the essential motive power for art in past ages. He wanted to substitute association for competition, to bring about a new and popular art 'which is now being crushed to death by the money-bags of competitive commerce'.[2] He wanted all artists and all classes to get together – literally. In a speech to Oxford undergraduates, Morris, perhaps thinking of his own marriage to an ostler's daughter whom he had met while painting the Oxford Union in the wonderful summer of 1857, told them to marry a woman from the lower classes. He wanted debates about art to centre on ways of developing the people's artistic instinct and brightening their environment:

I must ask you to extend the word art beyond those matters
which are consciously works of art, to take in not only painting
and sculpture and architecture, but the shapes and colours of
household goods, nay, even the arrangement of the fields for
tillage and pasture, the management of towns and of our
highways of all kinds – in a word to extend it to the aspect of all
the externals of our life.

he said in 'Art Under Plutocracy', a lecture delivered at University
College Oxford in 1883 with John Ruskin in the chair.[3]

The handful of socialist artists who followed Morris put his
dismissal of easel art into practice. The path of social realism had
been trodden in the 1870s and in the succeeding years enough
shoeshine boys, street arabs and newspaper sellers had walked
along it to fill up several boys' homes. But while the developing
social conscience of the age helped break down resistance to the
introduction into art of subjects centred on the suffering of the
lower classes, there is no evidence that the artists painted out of
any committment to social change. The politics of the best-known
social realists, Holl, Fildes and Herkomer, were closer to a
Dickensian caring than to any radical restructuring of society, and
significantly when socialism was gathering steam in the mid-1880s
all three turned to portraiture. Paradoxically, such pictures were
done by artists who appear to have been, if not politically
conservative, at least no more than fashionably sympathetic to the
sufferings of the poor, while the socialist artists, with the exception
of Moscheles, preferred to work in an allegorical style which
turned its back on naturalism. Loyal to their conviction that easel
painting had no role either in or in bringing about a brave new
world, the tiny band of socialist painters declined to develop social
realism as a weapon.

Anxious to show their break with fine art, they were drawn to
other locations than art galleries and other styles than narrative.
The most famous, Walter Crane, was wedded to allegory and
personification. Even before his conversion to socialism he had
never been keen on realism, his poeticising tendency giving rise to
oil paintings of literary or historical subject matter and his taste for
allegory drawing the poison of any satire he attempted.

After he had seen the socialist light, this taste for allegory and
personification continued. Although he tried to put his politics into
the easel paintings he continued to produce, he found it impossible
to paint a realistic representation of modern life. Everything turned
out in an allegorical-poetical manner, like *England's Emblem*,

shown at the New Gallery in 1895, in which St George charged the dragon against smoking factory chimneys. The imagery he used for the cartoons he drew for *Justice* and *The Commonweal*, which would be totally unintelligible without the legends weaving around the personifications, was the same as he used for his oils. In 1885 he exhibited *Freedom* at the Grosvenor Gallery (which he blamed for the gallery's owner Sir Coutts Lindsay's cold shoulder towards him). In it, the chains of a young nude prisoner lying between a feudal king and a priest fall from him as he sees the winged figure of Freedom. The iconography is close to *The Capitalist Vampire*, a cartoon in *Justice* in 1885, which showed the figure of Labour lying under the triple monster of religious hypocrisy, capitalism and party politics, while above stands the saviour, the winged angel of socialism, with torch and trumpet.

The bulk of the Royal Academy entries of the socialist sympathiser Henry Holiday were designs for the church windows in which he specialised, leavened by the odd historical subject. He reserved his social comment for murals and cartoons, like the eight-foot frescoes illustrating the progress from the reign of Mammon to the reign of humanity designed in the early 1890s for the Leighton Hall Neighbourhood Guild, a north London club for the education and mutual improvement of the area's working people. The only one to be almost completed showed a banqueting hall built over the labourers in mines and factories and labelled 'in the sweat of others' brows shalt thou eat delicacies'. Holiday's cover for the Guild's *Review* was adapted from the Awakening of Humanity design, depicting Love, Hope and Faith personified as women watching a female Light awaken the sleeping male Humanity.

An exception was the socialist painter Felix Moscheles, the editor of *Concord*, and according to Crane 'always an earnest Socialist, generally to be seen at the important meetings'.[4] He produced two series of social comment paintings which turned up in all the expected places. 'Pictures With a Purpose in the Year of Our Lord 1889' was exhibited when the Sunday Society got him to open his Cadogan Place studio and the five paintings in the group entitled 'In the Year of Our Lord 1892' were seen at the Canning Town picture show in 1895 and at Bermondsey in 1896. Even so, the portraits and landscapes he exhibited at the Royal Academy and West End galleries gave no hint of his socialist sympathies.

In *Arts and Crafts Essays* (1899) several members of the Arts and Crafts Exhibition Society use Morris's spectacles to see easel painting as an activity on the fringes of art. Walter Crane dreamed

of the days when artists like Dürer and Holbein were masters of all kinds of design, when fine art was linked with handicraft and 'where none is before or after another, none is greater or less than the other'. Ford Madox Brown advised readers to stop seeing painting as semi-sacred: 'it only remains for me to point to the fact that mural painting, when it has been practised by those who were at the same time easel painters, has invariably raised those painters to far higher flights and instances of style than they seem capable of in the smaller path.' Several years later, T. J. Cobden Sandersen explained that he wanted to extend the conception of art and to apply it to life as a whole, or 'inversely, to make the whole of life, in all its grandeur, as well as in all its delightful detail, the object of the action of Art and Craft.'[5]

The pictures for the poor reformers met the socialist attempts to redefine art with a wall of turned backs. As believers in the power of paintings to work miracles, Barnett and Co. were hardly likely to be attracted to a movement which saw fine art as an irrelevant possession of the rich. The revolutionary aspect of the socialist programme was also worrying for reformers who did not want to change society so much as improve the unsatisfactory bits of it: Barnett and his followers used art to clamp down radicalism, not aggravate it. In *All Sorts and Conditions of Men*, the hero explains how the arts can tame 'the reddest of redhot reds and the most advanced of Republicans':

> He shall learn to waltz . . . This will convert him from a
> fierce Republican to a merely enthusiastic Radical. Then
> he shall learn to sing in part: this will drop him down into
> advanced Liberalism. And if you can persuade him to attend
> your evenings, talk with the girls, or engage in some Art, say
> painting, he will become, quite naturally, a mere Conservative.[6]

From very early on, socialist ideas on the irrelevance of art got transmuted into a widely held view that socialism was antagonistic towards art. A political agitator in Henry James's *The Princess Casamassima* of 1886 is described as someone 'who would cut up the ceiling of the Veronese into strips so that everyone might have a little piece'.[7] The prejudice took hold and in 1907 a pamphlet called 'Socialism and Art' confronted it with the words 'upholders of the present capitalistic system talk in a vague sort of way about Socialism being destructive of art, without ever making any attempt to support this statement by serious argument'.[8] This view of the incompatibility of socialism and fine art guaranteed that supporters of pictures for the poor kept well away from theories

that appeared to threaten the very thing on which they had pinned their hopes for society's salvation.

It was not just the pictures for the poor movement which turned its back on Morris. The fine art establishment froze him out as well. In 1886, agitation began for a truly national art exhibition, in protest against the stranglehold of the Royal Academy which presented its summer exhibition as a national art show but in fact privileged its academicians in terms of exhibiting space over the non-Academicians who submitted their work to the jury. Although basically a painters' revolution, the socialists got mixed up in it as well. The envisaged new national art exhibition would have a jury of artists voted for by the artists themselves and – socialist-inspired development – would include all branches of the arts in its exhibits and not just painting and sculpture. Walter Crane was active in the campaign and never missed a chance to write to the newspapers and agitate for the inclusion of the crafts and decorative arts in the projected exhibition. The fight culminated in the foundation in 1888 of the New English Art Club, set up as an alternative exhibiting body for dissident painters displeased with the conservatism of the Royal Academy, and of the Arts and Crafts Exhibition Society, a body dedicated to the exhibition of art and craft work which credited its makers and designers. Although these organisations successfully broke the stranglehold of the Academy, they marked the defeat of the socialist dream to show the crafts and decorative arts alongside painting. Far from blurring the division between art and the crafts, the division was now institutionalised in the two organisations.

The freezing-out process was inevitable. The socialists were not dictating the terms of the debate but trying to change them – almost impossible when they involved shifting so time-honoured a notion as fine art. They were not helped when within a few years craft workers desirous of recognition for the artistic element and quality of their work began to put the adjective 'art' before their products. Nor were they helped by the subsequent reception of and changes in Morris's original ideas. It very soon became clear that only the revolutionary socialists accepted Morris's questioning of art and his demands for a new art emanating from a new lifestyle. It was far more common for his ideas about art to be used to dilute or amend the theories already in existence. For example, when Henry Holiday was asked by Fenner Brockway, editor of the *Labour Leader*, just before the First World War whether artists could use their art to inculcate higher principles, he replied that there was not much to be done in the ordinary exhibition but there

was great scope for murals in halls where people gathered.[9] In the inter-war years many members of the Labour Party (which, it should not be forgotten, had decided against using the word socialist in its title) saw their duty as one of bringing fine art to all as a right of all; some of them are still propping up Workers' Educational Associations today.

For all their dreams of uniting fine art and crafts, the socialists in practice underlined the division between the two. When they turned their backs on easel painting, their anti-art stance – as it was interpreted – left art with a clearer identity than ever. Paintings were left in the possession of the educated, the wealthy and the museums, their values intact and their powers to civilise unquestioned. Ideas about the social usefulness of art were to find their way into the thinking of the Fabians, the Labour Party and into assorted craft workshop experiments, and the dream of mental health and happiness through the practice of crafts led to the craft revival, amateur arts and crafts and today's community arts. Morris's writings influenced everyone from Gandhi to Tolstoy and they go on inspiring today. They were and are extremely powerful. But at the outset they failed in the battle against the exclusivity of traditional notions of fine art and they barely dented the standards, values and products of fine art, which sailed on serenely into the twentieth century.

PART III

The Legacy

14

The death of philanthropy

Pictures for the poor slowed down after 1900 and stopped by 1914. It went the way of many philanthropic exercises of the period, not dying exactly but being overtaken by a new model of getting art to the people. In the process, the belief in exposing the people to art was retained, but in the name of education instead of religion. And the task was increasingly taken over by the state and educational institutions. It was a common pattern at the time, a shedding of a worn-out skin on the journey to its modern appearance. Just as Octavia Hill's homes are a landmark on the path to state housing, Barnett's exhibitions are a stage on the road to the Arts Council.

It took the socialists to point out the holes in philanthropy. The cultural reformers understood that, inherited from an earlier era, philanthropy was unfitted for dealing with the modern problems of the urban poor, but they were prisoners of their thinking in that they could not see what to put in its place. The constant hand-wringings over the plight of the poor at the end of the century resulted in theories and projects of great originality, but they were still at heart philanthropy. Not until the socialists introduced the idea of state machinery as a way to redress social injustice could the efforts of philanthropists – even the up-to-date cultural variety – be seen as anything more than attempts to staunch the flow of blood with a brand-new sticking plaster.

The difference between the two groups centred on their attitudes to the poor and to society. The philanthropists saw that society had faults but none that a bit of tinkering and polishing could not improve. The socialists were unimpressed by the society that met their eyes from their new political vantage point and reckoned it would take drastic restructuring to make things fairer. The philanthropists wanted to uplift the poor to fit society while the

socialists saw better conditions of life as a right of the lower classes. It was a revolutionary development, for no longer were the poor the target of reform, but poverty. The socialist Beatrice Webb pin-pointed the philanthropists' assumption that any family could maintain its independence from cradle to grave provided its members were reasonable, industrious, thrifty, sober and dutiful:

> Thus any attempt by private or public expenditure to alter 'artificially' the economic environment of the manual-working class so as to lessen the severity of the 'natural' struggle for existence, must, they imagined, inevitably undermine these essential elements of personal character, and would, in the vast majority of cases, make the state of affairs worse than before, if not for the individual, at any rate for the class and the race.[1]

Webb was typical of the socialist thinkers whose ideas did so much to kill off philanthropy. Though there were not many of them in socialism's heroic decades, and though they often disagreed, the stir their ideas made was out of all proportion to their numbers. Through the Fabian Society, founded in 1884, some interesting thinkers expounded their hopes for an improved society; they may have been no more than a vocal minority, but they made the majority reassess its ideas. Their writings and speeches helped people see that capitalism needed a nudge if it was serious about ameliorating the lot of the poor; showed that charity – even the enlightened varieties – was unsatisfactory since it affected only the tip of the iceberg; and made philanthropy's hallmark of selectivity and elevation unfashionable by sowing doubt about expecting character reform in return for money and pointing to the numbers who fell through the nets.

Though not everyone was a socialist who accepted the socialist view of society, socialism's mindset helped people formulate the unease with existing philanthropic programmes which ultimately led to their disappearance. Just as the fresh perspective of the women's movement in the 1970s caused women – even those who refused to call themselves feminists – to question widely-held assumptions and attitudes, the late-nineteenth-century socialists saw through certain assumptions about charity's ability to care for the poor. And just as the women's movement based its findings on research, the socialists and their sympathisers gathered facts and figures to prove their case. Charles Booth's house-by-house investigation of London was typical of the new fact-finding approach to poverty, and the bleak findings, that about a quarter of the population lived on or below the poverty line of eighteen to

twenty-one shillings a week, offered a realistic view of the problems to be remedied.

Charles Booth himself accepted the socialist belief that the personal touch, although it worked in many cases, put a brake on large-scale operations, and he shared the conviction that it was hopeless to expect philanthropy in whatever guise and however sophisticated to solve the problem of the poor. About Whitechapel he wrote:

> Nowhere else are the leading churches so completely organised to cover the whole field of their work; and nowhere else are the auxiliary missions on so huge a scale. Money has been supplied without stint; the total expended is enormous; and behind and beneath it all, much of the work is sustained by the self devotion of very many and the exalted enthusiasm of not a few. It can hardly be but that the sense of present help and kindly sympathy brought home to the people must do good, and that the world would be a blacker world without it. But these results are difficult to gauge. Much that is done seems rather to do harm than good, and on the whole all this effort results in disappointment and causes men to turn to other methods.[2]

Booth brings the same polite but unconvinced tone to the question of elevation for East Enders. He had reservations about the People's Palace which, he wrote:

> stands out conspicuously in East London, as an attempt to improve and brighten the lives of the people. . . . It must be said that there is about both method employed and results obtained a sort of inflation unsound and dangerous. Hitherto, success has justified the measures taken, but nevertheless a slower growth for such an institution is much to be preferred, and it has even yet to be proved whether the People's Palace is to be regarded as an example or as a warning.[3]

The radical journalist Jack London was another who believed that social improvement could only stem from some sort of shake-up by the state. In *People of the Abyss*, published in 1903, he gives vent to his contempt for cultural philanthropy in a description of an exhibition at the brand-new Whitechapel Art Gallery:

> I have gone through an exhibition of Japanese Art, got up for the poor of Whitechapel with the idea of elevating them, of begetting in them yearnings of the Beautiful and True and Good. Granting (what is not so) that the poor folk are thus taught to

know and yearn after the Beautiful, and True and Good, the foul facts of their existence and the social law that dooms one in three to a public charity death, demonstrate that this knowledge and yearning will be only so much of an added curse to them. They will have so much more to forget than if they had never known and yearned. Did Destiny today bind me down to the life of an East End slave for the rest of my years, and did Destiny grant me but one wish, I should ask that I might forget all about the Beautiful and True and Good . . . and if Destiny didn't grant it, I am pretty confident that I should get drunk and forget it as often as possible.[4]

Selectivity and elevation were looked at with a caustic eye by Arthur Morrison in *A Child of the Jago*. Nothing works to ameliorate life in the Jago, Morrison's fictional version of the Old Nichol area on the boundaries of Shoreditch and Bethnal Green, which he knew intimately and which contained one of the worst slums in East London. One of the reasons nothing improved in Morrison's Jago was that the West End missionaries never came face to face with the truly poor: 'The East End, they reported, was nothing like what it was said to be. You could see much worse places up West. The people were quite a decent sort in their way: shocking Bounders, of course; but quite clean and quiet, and very comfortably dressed with ties and collars and watches.'[5] Morrison's novel exudes a pessimistic awareness of the way so many could fall through the nets provided for them, whether those nets were of culture, kind-hearted personal aid, or housing. His account of Dicky Perrot's visit to the opening ceremony of the new wing of the East End Elevation Mission and Pansophical Institute is a devastating illustration of his view of the uselessness of such cultural centres. His attack on the emptiness and irrelevance of the concept of elevation parodies every speaker who ever opened a loan art exhibition for the poor:

The Choral Society sang their lustiest, and there were speeches. Eminences expressed their surprise and delight at finding the people of the East End, gathered in the Institute building, so respectable and clean, thanks to persistent, indefatigable, unselfish Elevation.

 The good Bishop, amid clapping of hands and fluttering of handkerchiefs, piped cherubically of everything. He rejoiced to see that day, whereon the helping hand of the West was so unmistakably made apparent in the East. He rejoiced also to find himself in the midst of so admirably typical an assemblage –

so representative, if he might say so, of that great East End of London, thirsting and crying out for – for Elevation: for that – ah – Elevation which the fortunately circumstanced denizens of – of other places, had so munificently – laid on. The people of the East End had been sadly misrepresented – in popular periodicals and in – in other ways. The East End, he was convinced, was not so black as it was painted. (Applause.) He had but to look about him, *Etcetera, etcetera*. He questioned whether so well-conducted, morally-given, and respectable a gathering could be brought together in any West End parish with which he was acquainted. It was his most pleasant duty on this occasion – and so on and so forth.

There was a burst of applause in the hall: the new wing had been declared open. Then there was more singing, and after that much shuffling and tramping, for everybody was free to survey the new rooms on the way out; and the Importances from the platform came to find the tea.

Filling the room and standing about in little groups; chatting, munching, and sipping, while the sour-faced man distractedly floundered amid crockery: not a soul of them all perceived an inconsiderable small boy, ducking and dodging vaguely among legs and round skirts, making, from time to time, a silent snatch at a plate on a table: and presently he vanished altogether. Then the amiable Bishop, beaming over the tea-cup six inches from his chin, at two courtiers of the clergy, bethought him of a dinner engagement, and passed his hand downward over the rotundity of his waistcoat.

'Dear, dear,' said the Bishop, glancing down suddenly, 'Why – what's become of my watch?'

There hung three inches of black ribbon, with a cut end. The Bishop looked blankly at the Elevators about him.

Three streets off, Dicky Perrot, with his shut fist deep in his breech pocket and a gold watch in the fist, ran full drive for the Old Jago.[6]

The institutions which began to take responsibility for exposing the people to culture shied away from embarrassing and newly unfashionable terms like 'elevation'. Pictures for the poor fell into the hands of the new professionals in museums and education who replaced the missionary belief in art's power to refine with a missionary belief in art's power to educate. It was ironic that Barnett's Christian fervour had encouraged the process of professionalisation, secularisation and institutionalisation. Even

though he was responsible for the founding of the Whitechapel Art Gallery, he had always suspected that when the professionals took over, his dreams of preaching and moral teaching through art would collapse. In the *Daily Chronicle* of 10 December 1898, he wondered whether 'the comparative ease of arrangement may decrease the personal interest and service which has been the unobtrusive attraction of the old series of picture shows'. His fears were borne out within the gallery's first few years. By 1911, when its first director Charles Aitken left to run the Tate, the gallery had put on exhibitions of Pre-Raphaelite art, flower paintings, posters and a Jewish historical exhibition. Of course to modern eyes, it looks an eminently sensible choice of exhibitions for the locality, and by aiming exhibitions to appeal to the locals rather than to preach his religious beliefs, Aitken was sailing in the stream to the future.

In time, many of the voluntary practices of the loan exhibitions were taken up by state and institutions. In 1895, the Education Department declared that 'time spent during school hours in visiting museums, art galleries and other institutions of educational value may count towards the time required for attendance at school'. Although there had been a move afoot for years to get art and children together (by 1896 the Manchester Art Museum was circulating 240 sets of pictures to schools and training colleges, each one labelled with details of subject, technique and exhortations to strive for beauty, health and bodily strength), Henrietta Barnett claimed it was Whitechapel's success in getting teachers to bring their students to the exhibitions which had inspired the ruling. What *is* certain is that, as always, official policy was doing no more than endorsing the practice started by amateur enthusiasts.

In 1911 the first official guide started work in the British Museum and Henrietta claimed this innovation for Whitechapel, too. 'Thus the plan of guides, begun in 1881 in a back street in Whitechapel, grew, until we had the joy of knowing that Lord Sudeley's proposal that educated guides should be appointed for the public museums had been adopted not only for the leading treasure-houses of London, but in Kew Gardens and by the Leeds Municipal Art Gallery,' she wrote.[7] In the annals of museum history, it is Lord Sudeley alone who is credited with the move, opening his campaign with a letter to *The Times* of 9 October 1910 in which he asked for 'a race of intelligent guide demonstrators' to make the museums 'as attractive and educational as possible'. The only antecedents Lord Sudeley produced for his plan were the docents who lectured to the public in Boston and at the

Metropolitan Museum in New York. With not one word about Whitechapel's voluntary guides, Mrs Barnett's desire to give her husband a place in history is understandable.

In 1896, Sunday opening of museums was recommended by Parliament and this time the debt to Whitechapel was widely recognised. In the debate on 10 March 1896, Sir Samuel Montagu, member for Tower Hamlets, Whitechapel, cited the thousands who came to Whitechapel on Sundays, 'and this in spite of the fact that the Jewish residents went by preference on Saturday, their Sabbath, and the exhibition was held in badly-lighted schoolrooms difficult of access.' He thought the Sunday staffing problem could be solved by engaging the services of Jews or Mahomedans, who could be had as volunteers or at most at the cost of a few shillings each. Jews were so employed on Sundays in the reference library in Birmingham. 'Barnett', he said, 'has told me himself that the refining influence he has been able to exercise through the opening of museums has often had greater effect than any religious power he could bring to bear upon individuals.'[8] After the motion was passed, a letter appeared in *The Times* of 16 March 1896 from the Sunday Society, president Samuel A. Barnett, pleading for government funds for the Sunday afternoon opening of the major London museums and mentioning that it was sixteen years since the Sunday Society had first approached the British Museum on the subject. Barnett was just one voice in the choir of opinion that had a huge effect on cultural policies, but the fact that from 1881 he had been putting his ideas into practice made him a most important one. Other people could write and lecture, but Barnett could point to Whitechapel's guides, Sunday opening, and welcoming policy towards children, as rare and early examples of such ideas in action.

The final factor that won art for education was the change in art itself. As long as the nineteenth century followed Ruskin's rules of likeness to life and seriousness of ideas, the painters kept turning out art into which meaning could be read, the reformers could talk about the message and the poor could see with their own eyes whatever it was they were being told. But in the century's last two decades, these rules were forced to defend themselves against newer ideas inspired by French Impressionism. Since the 1860s, Whistler had deliberately set about undercutting expectations of what paintings should be about by claiming that their sole reason for existence was their colour and brushwork. It had been simple to dismiss him as an eccentric voice, but harder to ignore the generation who went to France in the 1880s like Sickert and Steer

and returned with the evidence of the new technique in their paintings. After 1905, art-lovers had to adjust to the English Post-Impressionists.

England was notoriously slow to take up these ideas in any wholehearted way. In an ungenerous refusal to admit anything was new, the critic R. M. Stevenson, in a widely read book, said that Velasquez had been an Impressionist two centuries before Impressionism. Someone like Samuel Barnett whose ideas on art were traditional was probably only vaguely aware of the changes. Even though it had an increasingly old-hat air about it, narrative art lived on until the First World War, ensconced particularly snugly at the Royal Academy summer show. Still, time was on the side of the avant-garde, and as the pendulum swung away from stories in paint, subject matter became less important than style, and the new stress on form, colour and technique made it hard to talk convincingly about art as a transparent window on the world. Pictures for the poor was defeated by its own weapons. It was hard to use art to teach lessons about life when the art employed to work miracles was now refusing to do the job.

With the change in the nature of art, no more could one convincingly claim, as Barnett had done, that artists were surrogates for God or that their works encouraged people to spiritual thoughts. The Victorian theory of preaching by pictures and the readable Victorian pictures went hand in hand. If ever there had been a time when art could plausibly be thought to benefit the poor, it was at the end of the nineteenth century when narrative paintings could be viewed as windows on an ideal world.

With the new art came new people to explain it. The shows of the Post-Impressionists in 1911 and 1912, at the Grafton Gallery, were accompanied by a new generation of critics. Just as Gauguin replaced Burne-Jones as most exciting painter, Roger Fry and Clive Bell replaced Ruskin as critics, taking it upon themselves to theorise the meaning and relevance of the new styles in art.

This art could not so easily be related to society, and people could not so easily understand it. Clive Bell wrote that 'art cannot march with humanity, progress, democracy or industrialism; it is tied to its own peculiar and perpetual problems. Art cannot come to the people: the people must come to art or leave it alone.'[9] By the outbreak of the First World War advanced art had removed itself to an enclave for the initiated. Strange to the eye, it required an aesthetic education to understand it. It was not possible to hold modern art up as an example of the perfect world. It demanded to be taken on its own terms as an object in that world, and people

were interested in discovering what those terms were. The age of art education had begun.

Barnett's exhibitions passed into history – not the section marked fame but the one marked silence. A clergyman who told the poor to look for motherhood in the eyes of a cow had little to say to a generation thrilled by Augustus John's sexual escapades and intrigued or enraged by abstraction. But though his movement was dead by the First World War, his ideas lived on in the continuing belief that it was good for the people to be exposed to art – Barnett's idea of art, untouched by socialist notions of the crafts and decorative arts. It seems all too symbolic of fine art's triumph that Walter Crane's exterior mosaic mural – that form of image-making so beloved by socialists – was not completed in time for the Whitechapel Art Gallery's opening. In 1914, pictures for the poor entered a dormant phase, to bloom again in the 1930s as Art for the People.

15

Art for the people

The Fry/Bell aesthetic theories were not challenged until the 1930s, and even then 'significant form' and 'aesthetic emotion', both ways of judging art on its own terms and not in relation to life, were not so much dethroned — for they still live on today — as joined by a new theory which said that art could only be healthy if it was firmly rooted in society. Many of the artists, critics and writers of the period were affected by marxist ideas, an influence which led to a revulsion against the establishment conception of art and the conviction that art should comment on, or reflect or relate to life in some way. This was the era when the artists put the people into their art. The Euston Road artists painted zoos and teashops, the poets wrote about the concerns and emotions of ordinary people in language which did not require a dictionary, and even Wigan was taken seriously. Mass Observation set about discovering what ordinary people felt and did and liked, cataloguing the objects on people's mantelpieces, discussing the success of the Lambeth Walk and turning northern washing lines into arty photographs.

The enemy for the left-wing artists and critics was Roger Fry's theory that paintings dealt in an area of aesthetic emotion far removed from the feelings of everyday life. Artists must above all 'be disabused of the notion that great works of art are produced by the aesthetic emotion alone,' wrote Roger Hinks. 'The painter and the architect can only flourish if they remain in immediate contact with everyday life and its immediate wants.' Hinks typifies the determinedly down-to-earth approach of the left-wingers. The renaissance of poster art was due to the facts that designers were 'prompted by the actual world' and that manufacturers lacked 'snobbish feelings about uplift' and realised that 'artistic intelligence and imagination' were more effective salesmen than the 'stupid and brutal philistinism' of Victorian commerce. Such critics believed

that it was inevitable that the aesthetic aspects of a material civilisation should be found in material objects, in aeroplanes, motor cars, suitcases and tennis rackets. Even 'purely aesthetic' artists do their best work when satisfying a client, like Picasso's dress designs for *The Three-Cornered Hat* and Duncan Grant's patterns for textiles.

Despite their democratic approach to art, these critics and artists were not iconoclasts. They clung to a two-tier set-up in which applied art was not art's highest form. As Hinks said:

> The greatest art is an instrument of spiritual contemplation. . . .
> Only a religious revival of overwhelming power can produce
> that miracle, or possibly some political event of such significance
> that it ranks almost as a religious event. Such no doubt was the
> outbreak of Communism as a world force – it can hardly be
> denied that one of the very few powerful imaginative artists
> today is precisely the Mexican communist Diego Rivera.[1]

Adult education expanded in the 1930s, underpinned by the committment to extending university-standard teaching to those who through the bad luck of the social lottery had missed out on it – an attitude still found among the elders of today's extra-mural departments. The adult education dream had the wireless on its side. In one talk about art, the BBC reached more members of the working classes than Barnett had in all his exhibitions. It was typical of the times that a young marxist called Anthony Blunt made a plea for the validity of any approach – however untraditional – in making art accessible to all. He described a Van Gogh exhibition in Paris at which the artist's letters were displayed alongside the paintings mentioned in them. 'People go from the letters to the paintings, and who is to argue with that as a way of bringing people to art?' he asked in the *Spectator*.

This missionary approach to spreading the higher educational word dictated the kind of knowledge that was imparted. Inevitably the art that was taught was the art that had been pre-digested by the academic and gallery worlds and this meant that art appreciation and art history dominated the curriculum. When it came to getting the artistically uneducated to appreciate fine art, the Barnett showing and telling approach was favoured over the do-it-yourself Morris approach, and even when making was offered instead of listening, fine art still retained its privileged position. The well-known Ashington Project, a Workers' Educational Association art class which resulted in miners painting pictures, was actually an art appreciation class, and not the tapping-the-talent-in-everyone

experiment presented by the followers of Morris in the 1970s. Robert Lyon described how art appreciation, as much as practice, was the goal:

> The outcome of the class, apart from the work produced (which is not important compared with the aim of the course in stimulating an appreciation of art) encourages me to believe that the scheme is capable of further development, not only in Ashington, but elsewhere and in conjunction with other types of classes and or organisations whose object is to develop the individual power of expression through deeper and more honest understanding.[2]

Julian Trevelyan recalls how he arranged an exhibition with Robert Lyon at a Gateshead Goods Works Settlement 'of what, for want of a better name, we called "Unprofessional Painting"'. The title is revealing of the organisers' attitudes.

> Since then the idea of self-expression has become a commonplace and England is flooded with indifferent art by amateurs – there are even Butlin camps for painting, and my enthusiasm for popular painting has waned somewhat as I see what it has produced, or rather how rarely one finds anyone with a spark of originality or vision. Its value I suppose is that it keeps lot of people happy and perhaps to some extent leads them to a greater understanding of what painters are trying to do.[3]

Little dent was made in the 1930s in the traditional idea of fine art as something done by professionals which non-professionals could appreciate but not produce. For all the interest in getting art and the people together, there was little conviction that the art produced by the people was worthy of respect. An East End Academy was held each year in the 1930s, as East London's answer to the Royal Academy, of amateurs, art school students and local artists. No one seems to have noticed that transferring the high art label to amateur artists might seem patronising or to have picked up the suggestion of parody.

It was in the 1930s that Barnett was rescued from history's silence. W. E. Williams of the British Institute of Adult Education began an experiment of providing loan exhibitions of pictures to English towns without art galleries, beginning in March 1935 with shows in Barnsley, Silver End and Swindon. The scheme was called Art for the People, and in the Institute's pamphlet, Barnett was given credit for the idea:

It is not an original policy, although for some time it has been a neglected policy in England at any rate. . . . Fifty years ago Canon Barnett practised it in the wilderness of Whitechapel. The Millets and Holman Hunts which he borrowed year after year for the East End audience may be outmoded now; there may, too, be something of sentiment too florid for our taste in his pronouncement about pictures being 'unknown tongues speaking truth'. But when all allowance has been made for changes of idiom, his avowed intention was at most points similar to that of the Institute's recent experiment.[4]

The exhibitions were based on Henrietta Barnett's description of the Whitechapel shows in her biography of her husband, which had gone into three editions between 1918 and 1921. All the paintings were loaned; the goal was the exposure of people to the rare experience of looking at pictures; opening was at Easter; children were welcomed; there was voting for favourite paintings; entrance was free; talks were given and guides introduced into the galleries with the purpose of stimulating impromptu discussions.

The main difference was that the organisers saw the shows as an arm of adult education. In the enlightened 1930s, it was old-fashioned to talk in terms of refining the poor, or of using the pictures to teach spiritual truths. The Victorian age, against which the up-to-date measured their modernity, had taught the teachers that it was wrong to patronise the people and unrealistic to expect miracles: 'It would be nonsense to suggest that these collections of good original pictures took Swindon or Barnsley or Silver End by storm; that they diminished the size of the local cinema audiences' (the 1930s substitute for public houses?) 'or denuded the publican of his customers. What they did do was to attract more than 10,000 adults and many hundred parties of schoolchildren.'[5]

The goal of the experiment was to fight artistic illiteracy, which was felt to be chronic but not incurable. It did this by giving the public 'the opportunity of making up their minds about the pictures they like or of formulating a set of independent opinions about them' and by giving 'people who seldom see a good picture the chance to see a selection of the best that can be got together'.[6] The adult educationalists behind the scheme also hoped that the people would become more tolerant of the new artistic styles like abstraction and surrealism: 'An understanding that art can do more, should do more, than reproduce similitude of the visible world can only come by more opportunities for acclimatization to the new idiom and the new intention.'[7]

The experiment was immensely successful. All kinds of grand names were sucked into it as exhibitors, helpers or well-wishers. In 1937, the Institute developed a circulating service of reproductions as a way of following up exhibitions or bringing art to out-of-the way places and worthy institutions like unemployed clubs.

When the Council for the Encouragement of Music and the Arts was set up at the outbreak of war in 1939 to keep the cultural home fires burning, it subsidised Art for the People, the only art organisation to be so favoured. The war was a boom period for the arts, and there are many people who look back on the CEMA years as a golden age of culture. Yehudi Menuhin played the violin in small towns and villages. Theatre groups acted to enthusiastic audiences in town halls. Ballet developed a new public. Dame Myra Hess played the piano in the National Gallery to bare walls but audiences of hundreds. For every cynic who claims that people went because it was all there was to do in a country at war, there are ten who attribute their interest in the arts to their wartime accessibility. Art for the People had a good war, too. In 1940 it offered eighty exhibitions to nearly 300,000 visitors. In 1941, it branched out, extending the subject matter of its shows to include material on town planning and extending its reach by exhibiting in canteens, hostels, munitions factories, army camps and study centres. When on 12 June 1945 the Chancellor of the Exchequer announced that CEMA would continue as a permanent organisation with the title of Arts Council of Great Britain, the future of Art for the People seemed secure.

For a few years while it was feeling its way, the Arts Council continued CEMA's policy of funding the British Institute of Adult Education exhibitions. But the Arts Council was producing its own exhibitions at the same time, and overlap and conflict developed. Art for the People was told that its exhibitions in village halls and small galleries were duplicating those organised and toured by the Council. In 1949, the Arts Council took over Art for the People, reorganising it in line with its own exhibition policy. The run-up to the Festival of Britain was under way, and the Council was busy commissioning murals and art works from British artists. It is not surprising that in this expansionist and exciting climate, the village hall aspect of the Institute's work lost favour.

The takeover was bitterly greeted at the Art for the People offices. The organisers had a strong sense of the difference they had made to people's awareness of the visual arts. The Institute's journal quoted Sir Kenneth Clark's remark that none of the seventy

town clerks he had met in the war had seen an original picture. The magazine remarked pointedly:

> Perhaps some of these hard-worked officials (and the millions like them) will have travelled to London, visited one of the major galleries and seen an original painting. But it is more likely that on their own doorstep – in their local history library, for example – they have almost by accident, slipped into an Art for the People exhibition and had their imaginations strangely stirred for it.[8]

It must have been heart breaking to lose control of a programme which had grown from educational scheme to success in so short a time. But it supplies a tidy conclusion to Barnett's involvement in this story, for the takeover meant that his dream of bringing the best modern art to all was woven into the post-war policies of the Arts Council.

Barnett is also important on a more general level. His agitation for access to the arts for everyone makes him a symbol of all the nineteenth-century thinkers and doers whose belief in the importance of culture for the lower classes led to the Labour Party's decision to offer the cultural heritage to all. In April 1945, before the election which put them into power, the Labour Party issued its policy document *Let Us Face The Future*. Under 'Education and Recreation' appeared the following sentence: 'By the provision of concert halls, modern libraries, theatres and suitable civic centres, we desire to assure to our people full access to the great heritage of culture in this nation.' With this document, the Labour Party committed itself to supplying culture to the people, a committment embodied in the creation of the Arts Council. Although it was stressed that the Arts Council was to be independent of government control – the arm's length policy – the fact that its money came from the Treasury meant that it was in effect the arts branch of the welfare state. Henceforth, the arts were to be supplied for the nation's intellectual health as medicines were for its physical health, and Barnett's dream of 'nationalising the better part of the nation's wealth' looked set to become reality.

The legacy

Like all newborns, the Fine Art Panel of the Arts Council inherited the values of its ancestors – art's power to civilise and the belief in showing the best paintings to the people from its grandparents, the need for the people to be educated to appreciate art from its parents.

Although these beliefs were its inheritance, they were not all embraced with equal enthusiasm. There was no difficulty at all about exhibiting the best. The Art Panel's conviction that it had the professional knowledge and resources to exhibit art of the finest quality was one of the reasons for its farewell handshake to the earnest but insufficiently grand exhibitions of Art for the People. There was no disagreement with art's civilising potential either, although it was restated in twentieth-century terms of appreciation of art as the hallmark of the cultured and refined. The Council had less enthusiasm about educating, despite the fact that the duty to do so – 'to develop and improve the knowledge, understanding and practice of the arts' – was written on its birth certificate. It had excellent reasons for not living up to its responsibilities in this area, like lack of funds and the need to concentrate on mounting the finest exhibitions of painting and sculpture. But the real reason was that deep down the Arts Council felt that exhibiting, not educating, was its primary job and that the agencies concerned with adult education could handle that sort of thing much better. The Morris philosophy, whereby all would be given the chance to practise an art or a craft or the state would use the arts to bring about a wholesale improvement in the environment and quality of life, never held much interest for those who ran the organisation, just as they had never attracted its ancestors. The idea of do-it-yourself art was always seen as someone else's responsibility, and besides, the phrase 'to develop and improve the practice of the arts' was

ambiguous – it could as easily mean raising the quality of professional artists as encouraging amateurs to have a go.

Policies have varied according to fashion and available funds, but over the past forty years the major part of fine art funding has gone on the purchase of contemporary painting and sculpture, on the support of artists and above all on blockbuster exhibitions of old masters or contemporary art. Having accepted from the start the traditional interpretation of fine art, the Council immediately pushed out from its nest anything that did not fit the definition. It froze out what it considered fringe elements by enshrining its definition of art in the structure it used to organise the art world. The shape of things to come was signalled in its first year with the 'Design at Home' exhibition described as an 'epilogue' to exhibitions organised by the British Institute of Adult Education and a welcome to the Council of Industrial Design.[1] The practice of sending off areas which were not strictly fine art into organisations of their own or into someone else's care would be repeated in years to come. It happened to sculpture in public places, to the crafts, and most recently to the community arts which were handed over to the regional arts associations at the end of the 1970s. The official line, that it enabled these areas to develop their own strong identity, was true, but it also left fine art with an identity more clearly defined and inviolate than ever.

It was clear from the start, particularly with the success of the war years behind them, that an informed and sympathetic audience was hungry for art, and the Council's job became increasingly one of serving that need and acquitting itself well on the national and international exhibition circuit. The 1954 Report stated that the

> segment of the population which had already cultivated an appetite for the arts is large and loyal. . . . It is true that masses of people will lay out a pound or two on a coach visit from Coventry to an ice show at Earls Court . . . but these free-spending citizens are not as a rule supporters of our symphony orchestras and repertory theatres.[2]

In the 1950s and 1960s an interest in the arts grew along with the economy; the ever-increasing exhibition audience meant that though the Art Panel accepted its duty to convert, it could legitimately spend most of its time feeding the existing audience. Nonetheless, the Arts Council's guiding principles made it inevitable that certain nineteenth-century attitudes would survive into the twentieth century.

To begin with, it only gave its attention to a certain kind of art.

Apart from favoured exceptions like Bernard Leach pots and stained glass by fine artists like Graham Sutherland, the Council limited its exhibitions and purchases to paintings and sculptures by the 'best' artists. Defining the best was done by distinguishing amateur from professional practice. The Council neither funded amateur art nor looked on it with enthusiasm. In 1951 it noted 'with regret' how few art clubs and societies managed to develop a constructive programme of activity or pass beyond the dilettante stage. In 1956 it stated that the achievement and preservation of standards in the arts is primarily the role of the professionals. In 1958 it was disparaging about library-galleries, amateur art societies and photographic clubs. In 1964 it asked if there was a case for a special body, 'perhaps on the lines of the proposed Sports Council', to deal with amateur activities as part of a 'youth service' or as part of some wider general service concerned with public provision for leisure.[3] In 1947, an art students' exhibition was organised, a nod to the professional structure by which artists were made.

Inevitably its role as modern-day patron, collector and exhibitor dictated its duties and attitudes.

> In the USA, where redistribution of wealth has not been so drastically carried out as it has here, the arts are still largely sustained by the munificence of private patronage. But in Britain, where the redistribution of wealth has become an axiom of government, the wealthy patron is dying out . . . and if the arts are to survive in the egalitarian state, some form or forms of collective patronage must assume the obligations formerly sustained by the private benefactor.[4]

This nod to the idea of collective patronage was frequently made: 'No taxpayer,' it announced in 1953, 'can contract out of the upkeep of amenities and necessities of the welfare state, including preservation of the fine arts.'[5] In reality, the taxpayers had as little to do with what was bought and exhibited in their name as they did in Barnett's day. The Council took its duties seriously and was determined to be an enlightened patron, spreading the word about modern art – however 'hard' – like the British Council of Adult Education before it. And like the pictures for the poor reformers even further before it, you can hear its sigh of relief when the art in the Open Air Sculpture exhibition in Battersea Park in 1948 survived unharmed: 'it was satisfactory that there was no attempt of any kind while the exhibition was open – and highly accessible to the public – to deface any of the exhibits.'[6]

The Council's view of itself as guardian and dispenser of quality slips out in the metaphors explaining its work:

> In the first place, we can reasonably expect our patients to be willing. Anything we can do to help people to appreciate works of art is directly enabling them to enjoy life more. . . . There may not be enough of our medicine to go around but at least it is not nasty medicine. . . . One of our oldest established lines of business is in exhibitions of paintings and sculpture – last year more than 175,000 people came to these exhibitions in London and perhaps twice as many in the provinces.

More art could mean only one thing, a better life: 'We are in the mainstream of a current of activity that flows irresistibly towards a finer and more splendid life for our own people.'[7]

The stress on the best fine art, the dismissal of the amateur, the guardianship of quality, the belief that art was good for people, like medicine or high-class consumer goods, the conviction that art could improve life – it was as if the socialist pronouncements of the 1880s had never been made, as if Walter Crane had never said that

> art exhibitions have hitherto tended to foster the prevalent notion that the term 'Art' is limited to the more expensive kind of portable picture painting, unmindful of the truth that the test of the condition of the arts in any age must be sought in the state of the crafts of design.

With Lord Goodman in the chair, the Council toed the nineteenth-century line that the arts had a role to play in solving social problems. In the House of Lords on 19 April 1967, he said he believed that

> young people lack values, lack certainties, lack guidance; that they need something to turn to – and need it more desperately than they have needed it at any time in our history – certainly at any time which I can recollect. I do not say that the Arts will furnish a total solution, but I believe that the Arts will furnish some solution. I believe that once young people are captured for the Arts, they are redeemed from any of the dangers which confront them at the moment. . . .[8]

The strength of this nineteenth-century view of art as a means of redemption was tested at the end of the 1960s when new art movements came along to confuse the Council. It was difficult to consider such art as a vessel of quality and in 1969, the chairman announced that 'what we are now trying to do is to ascertain

whether the considerable experimental activities in which many
young people now engage, which deliberately discard the conventions
and standards and methods of other generations, can sensibly be
helped or should be helped by us'. The Council admitted that the
judgmental carpet was being pulled from under its feet. In the same
Report the Secretary General said:

> What should the Council's attitude be to a quite wide movement
> among a young generation, a coming together in the name of the
> Arts, in all parts of the country, in laboratories, workshops and
> groups? There is a great interest here in a mixed media and
> modern technology and an indifference to existing forms and
> traditional methods of provision. The normal methods of
> assessment, artistic and financial, can hardly be applied.[9]

As it turned out, traditional methods of assessment were able to
cope with nearly all the developments. Indulgence to the avant-
garde, so long as it had been properly trained in art schools, was a
mark of a sophisticated artistic appreciation. If the art events of the
past hundred years had taught the cultural leaders anything, it was
that they ignored new movements at their peril. Though money
became tighter in the early 1970s, the Council took funds from the
established arts for art films, performance art and photography. In
that way the Council was able to hedge its bets for a very small part
of its budget, the major part of which went, as always, on mounting
exhibitions, funding galleries and buying modern art, and in the
process to show itself an enlightened patron of the avant-garde.

The one new area which caused problems was the community
art movement, which the Council defined as 'the activity of artists
in various art forms working in a particular community, and
involving the participation of members of that community'.[10]
Within the class system of art, community art was guaranteed to
come off badly. Given that class one of art was visual art validated
by museums, auctions and art history, community art had little
hope of being taken seriously by the Art Panel in any other way
than as a problem to be dealt with. On the Arts Council's
reckoning, it failed to be art on all counts; it was produced by
amateurs; it did not display art school origins; it was frequently
critical of society; and it could not be neatly packaged for gallery
display. In their place, community art stressed values like partici-
pation and self-expression which had more to do with social health
than with the values traditionally associated with art. Though the
Council's duty was to sustain innovation in the fine arts, it was not
sure that this professional-amateur hybrid qualified.

Philosophically and politically, the community arts movement was at odds with the Arts Council. The community arts represented as great an attack on the fine arts as the socialist ideas of a century earlier. The Barnett-Morris confrontation repeated itself with the Arts Council standing for traditional top-quality painting and sculpture done by professionals and the community artists questioning the 'sterility of many of the art forms so eagerly bought, sold and promoted during the century', and dreaming of establishing 'a vernacular vocabulary of artistic expression'.[11] Like Morris, community artists felt that art and artists had lost touch with life. Like Morris they were not interested in spreading the knowledge of paintings which they saw as the property of an elite made up of the educated and upper classes. Like Morris, they believed the arts were socially necessary and not just desirable. Like Morris, they wanted an art to develop from the people. Like Morris, they were after an artistic democracy, with everyone taking part.

The theory behind the community arts made great headway in the 1970s with books, conferences, and statements from the UN promoting its principles. But one place where its advance was resisted was the Arts Council. Lord Gibson wrote:

> There is, however, a new creed emerging to which we are totally opposed. This is the belief that because standards have been set by the traditional arts and because those arts are little enjoyed by the broad mass of people, the concept of quality is 'irrelevant'. The term cultural democracy has been invoked by those who think in this way, to describe a policy which rejects discrimination between good and bad and cherishes the romantic notion that there is a 'cultural dynamism' in the people which will emerge if only they can be liberated from the cultural values hitherto accepted by an elite and from what one European 'cultural expert' has recently called 'the cultural colonization of the middle classes'.[12]

The New Secretary-General, Roy Shaw, was another who tirelessly picked off the new claims. In 1976, the Conference of Ministers of the Arts at Oslo inspired his scorn:

> I found at Oslo that many of my fellow experts from Europe cared too little for what they sometimes disparagingly refer to as 'the heritage concept of culture'. . . . Quality, they assure me, was a purely subjective concept, far too vague to use in cultural policy. A few people in Britain say the same, advocating

'relevance' as an alternative to qualitative standards. If not
resisted, such thinking could gradually subvert any cultural
policy, and produce a situation where 'anything goes'.[13]

The accusation that high art was elitist or bourgeois enraged
him. In 1977, he referred to a popular dramatist who was reported
to have repudiated a play with the words, 'to appreciate that form
of theatre, you need experience of higher education, and that's the
politics of elitism':

> Where art required higher education to be appreciated, it is
> absurd to call the art itself 'bourgeois' – it is the access to a
> higher education which has in the past been restricted. The
> remedy is not to replace complex and difficult art with that
> which makes an instant appeal to everyone – it is to develop arts
> education at all age levels.

He equated the community artists' view that the masses will never
be capable of enjoying the best in the arts with that held by mass
entertainers – both underestimate people. He even returned to the
nineteenth century for ammunition, quoting Matthew Arnold's
view that 'the true men of culture would seek to do away with the
distinction between the masses and the classes, and would seek to
make the best of the arts available "outside the clique of the
cultivated and learned" '.[14]

In 1978 Su Braden published *Artists and People*, a defence of the
community arts in which the hostility to the cultural heritage idea
of art was spelled out clearly. Sir Roy referred to it in the Annual
Report, quoting what he called the author's extraordinary state-
ment that the 'so-called cultural heritage which made Europe great
– the Bachs and Beethovens, the Shakespeares and Dantes, the
Constables and Titians – is no longer communicating anything to
the vast majority of Europe's population . . . it is bourgeois culture
and therefore only immediately meaningful to that group. The
great artistic deception of the twentieth century has been to insist
to *all* people that this was *their* culture. The Arts Council of Great
Britain was established on this premise.' Sir Roy met the challenge:

> Against this I would argue that the great democratic task of the
> twentieth century is to initiate more people into an awareness
> that the culture which they felt was 'not for us' really *is* 'their
> culture' . . . to dismiss Europe's cultural heritage as 'bourgeois
> culture' is simply politically inspired philistinism.[15]

Sir Roy did not like the community arts any more than their

theory, admitting that the community artists were the most difficult clients for the Arts Council to deal with. 'It is not easy to work with artists who not only consistently bite the hand that feeds them (a fairly general practice) but often explicitly repudiate the basic premise of the Arts Council's charter.'[16]

One of the things that made the community artists a ceaseless irritant for the Council was the way their actions and beliefs put its own cherished views up against the wall. For example, it took the outspokenly critical artists of the 1970s to expose the pious belief in the artist's divine right to comment on the society above which he hovers (the artist is always male in this line of thought) for the hypocrisy it was. One can hardly blame the Art Panel for looking with a less than kindly eye on work that wanted to shake up the status quo, but its reaction does expose the weak spot in its assertion that artists were free to speak out, and the flaw in the arm's length policy's pride in supplying money without conditions. It was one thing in 1948 to bravely present modern sculpture to the public in its role of enlightened patron, but quite another to fund art which sneered at the traditional arts, criticised society and dreamed of social revolution. Said Sir Roy Shaw in 1979:

> Lord Goodman, chairman of the Arts Council, questioned whether it was the duty of the state actually to subsidise those who are working to overthrow it. . . . It is a point the Arts Council will have to consider carefully when it studies a research report on community artists later in 1979, though it is unlikely to deny that the artist has an important role as a critic and prophet in a democratic society.[17]

Despite the dislike of the philosophy, and the disbelief that anything which combined 'aspects of performance art with social and welfare activities'[18] could properly count as art, community arts were funded for several years. The one ace they held was their claim to be generating a new audience for the arts, a claim which the Council found convincing. 'Many people who have had no chance to enjoy the arts can be helped to approach them by being encouraged to participate in creative activities rather than merely to experience it passively. It is this feature of community art which is of particular interest to the Council,' wrote the chairman in 1976. 'It is still too early to say how significant this movement may become,' said Sir Roy Shaw in the same year. 'Already, in many areas, some people who had rejected what they felt to be "elitist arts" have through participation come to see that the arts have something to offer them.'[19]

In deference to their proselytising powers, the Council upped the community arts' subsidy from a quarter to one million pounds between 1974 and 1978. But the Council was never wholeheartedly in favour of them. It was constantly on the look-out for funding agencies to help share the costs, and in 1976 it renewed its faith in its original decision to keep art 'fine' by pushing for the regional arts associations and local authorities to take over the community arts. In 1978–9 it rather ungraciously stated that had taken the community arts in because no one else would, and suggested that because they mixed social and educational work with art they should be financed by schemes like urban aid. In 1980 it announced with relief that the process of devolving the community arts would be completed by 1982. In 1983, Sir Roy Shaw was able to reaffirm his belief in the viewing, not the doing, of art:

> For some arts educators and many community artists appreciation is a dirty word and participation – doing your own thing – is the preferred approach to artistic experience. So Redcliffe-Maud quoted (with apparent approval) a community artist who said: 'Hanging a picture on a wall and inviting people to come and look at it is the easiest possible thing to do. We are trying to do something much harder: to tap the creativity in everyone.'
>
> This statement seems to me to combine arrogance with ignorance of what is involved in the appreciation of art, which it dismisses as merely passive as opposed to the activity of doing it yourself. . . . Encouraging appreciation means precisely helping people to perceive the qualities of a work of art and those who dismiss it may do so because they themselves are blind to the qualities of the best in the arts and know only the satisfaction of doing your own thing. . . . I have always maintained that we need both the appreciation and participation approaches, and have said publicly that a good community artist can be a 'centre of excellence'.
>
> I oppose only those community artists who themselves oppose attempting to develop appreciation of the artistic heritage and the best of present-day arts. . . . For to reject the arts tradition in favour of 'doing your own thing' is philistine and narcissistic.[20]

The community arts controversy was a repeat of the Morris dream to broaden the concept of fine art, and a repeat of the defeat. Morris and his followers had hoped to break into the citadel of the Royal Academy and get recognition for the crafts. The community artists had hoped to be generously funded by the official dispenser

of money for the arts. In both cases, the official body froze them out.

This is not to deny that they had an effect. In 1978 the community arts section and the visual arts department established a scheme for mural and environmental projects in the belief that artists have an important contribution to make in improving the deteriorating inner-city environment. The community arts still live, just as Morris's ideas are still an inspiration today. Morris's ideas transformed much of British thinking about the crafts and the relation of art to life, and the community artists brought pleasure, involvement, excitement and environmental improvements to thousands previously untouched by the arts. But neither Morris nor the community arts changed art. Art is still what it was in the nineteenth century: paintings and sculptures done by professionals, exhibited in galleries, regarded kindly by publishers and taught about in art history classes. And the perception of its powers has not changed significantly. An appreciation of it is still thought to make us more refined, sensitive and civilised. In an argument for tax concessions to be granted to private collectors who share their art with the public, *The Times* salesroom correspondent wrote in April 1985 that 'educators have long acknowledged the civilising influence of art, quite apart from its popular appeal'. Whether she believed it or not is unimportant. What matters is that art as a civilising influence and hence a social benefit was a respectable argument to use in her cause.

The challenges to this notion of art remain outside art, taking the form of environmental art, hospital art, school art, mural art, night school art and community art. They exist outside art proper, and because they are outside they strengthen fine art's sense of identity and self-confidence and lessen their own chances of success. These forms of art are an alternative art, an alternative to 'real' art, with little hope of prestige or success because of that. By concentrating its fine art funds on what the late nineteenth-century socialists called easel art, the Council has played a part in shoring up the ideas of art as something done by professionally trained artists, exhibited in galleries, described in art history and admired by the public.

With the increasing switch from government funding to private sponsorship it will be interesting to see whether the concept of fine art is changed in any way with private corporations as paymaster. On the existing evidence it is unlikely, for anyone spending money wants to spend it on something prestigious and though, thanks to Morris, the idea of what art is has broadened, thanks to Barnett the idea of what is prestigious art has not changed at all.

Notes

Chapter 2

1 Select Committee appointed to enquire into the best means of extending a knowledge of the arts and of the principles of design among the people (especially the manufacturing population of the country); also to enquire into the constitution, management and effects of institutions connected with the arts; and to whom the petitions of artists and admirers of the fine arts, and of several members of the Society of British Artists, were severally referred; 1835–6, Report, p. vi.
2 Ibid., II, 590.
3 Ibid., Report, p. v.
4 Ibid., I, 1460.
5 Ibid., II, 316, 317.
6 Ibid., I, 1356.
7 Ibid., Report, p. x.

Chapter 3

1 Select Committee appointed to inquire into National Monuments and Works of Art in Westminster Abbey, in St Paul's Cathedral, and in other Public Edifices; to consider the best means for their protection, and for affording Facilities to the Public for their Inspection, as a means of moral and intellectual improvement for the people; 1841, Report.
2 Ibid., Report, p. vi.
3 Select Committee appointed to inquire into the promotion of fine arts of this country, in connexion with the rebuilding of the Houses of Parliament; 1841, Report, p. v.
4 Select Committee appointed to inquire into the management of the National Gallery; also, to consider in what mode the collective Monuments of Antiquity and Fine Art possessed by the Nation may be most securely preserved, judiciously augmented and advantageously exhibited to the public; 1852–3, Report. Evidence of W. Coningham, 7018–22.
5 Ibid., 7390, 7392.
6 Select Committee appointed to inquire into the promotion of fine arts of this country, op. cit., Report p. vi.

7 Ibid., Report, p. vi.
8 Ibid., 859, 861.
9 National Monuments Commission, 2672, 2655.
10 Ibid., 1841, p. 91 and Report, p. vi.
11 Ibid., 2960 to 2971.
12 Ibid., 3156.
13 Select Committee on the National Gallery 1852–3, 8014–16.

Chapter 4

1 John Ruskin, *The Works of Ruskin*, Library Edition, 39 vols, ed.
E. T. Cook and A. Weddernburn, London, 1903–12, vol. 10, *The Stones of Venice*, 1851–3, p. 196.
2 Matthew Arnold, *The Complete Prose Works of Matthew Arnold*, ed.
R. H. Super, Michigan, 1975, *Culture and Anarchy*, (1867–69), vol. 5, ch. 1.
3 Ruskin, op. cit., vol. 10, p. 222.
4 *Bermondsey Settlement Magazine*, June 1896.
5 Ruskin, op. cit., vol. 5, *Modern Painters*, 1856, p. 42.
6 Mary Booth, *Charles Booth: A Memoir*, London, 1918, pp. 13, 14.

Chapter 5

1 Samuel and Henrietta Barnett, 'Class Divisions in Great Cities', from *Towards Social Reform*, London 1909, p. 31.
2 Henrietta Barnett, *Canon Barnett, His Life, Works and Friends*, 2 vols, London 1918, vol. 1, p. 76.
3 Ibid., vol. 1, p. 78.
4 'Whitechapel Loan Art Exhibition', The *Tower Hamlets Independent*, 8 April 1882.
5 Ibid., 12 April 1884.
6 *East London Advertiser*, 4 April 1896, p. 7.
7 T. C. Horsfall, *The Relation of Art to the Welfare of the Inhabitants of English Towns*, Manchester, 1894, p. 8.
8 Ibid., p. 3.
9 Ibid., p. 4.
10 Ibid., p. 5.
11 Walter Besant, *All Sorts and Conditions of Men* (1882), London, 1883, p. 138.
12 Walter Besant, *Autobiography of Sir Walter Besant*, London, 1902, p. 245.
13 Samuel Augustus Barnett to Francis Barnett, 29 October 1887, County Hall Archive.
14 Besant, *All Sorts and Conditions of Men*, p. 125.
15 Ibid., p. 54.
16 Ibid., pp. 125, 6.
17 Henrietta Barnett, op. cit., vol. 1, pp. 75–6.
18 Letter printed in Horsfall, op. cit., p. 20.
19 Besant, *All Sorts and Conditions of Men*, p. 82.
20 Ibid., p. 138.
21 Octavia Hill, *Homes of the London Poor*, London, 1875, p. 7.

Chapter 6

1 *The People's Journal*, 28 November 1846, vol. 2, p. 296.
2 Ibid., 5 December 1846, vol. 2, p. 311.
3 Report on the system of circulation of art objects on loan from the South Kensington Museum for exhibition as carried on by the Department from its establishment to the present time, 1881, p. 20.
4 Walter Besant, 'Art and Handwork for the People', Manchester, 1885, p. 21, one of three published papers read before the Social Science Congress, September 1884.
5 The *Sunday Review*, journal of the Sunday Society, January 1879, vols 3–4, pp. 103–4.
6 The *Sunday Review* has accounts of these letters in vols 3–4 and 5–6.

Chapter 7

1 The *Municipal Journal*, 8 March 1901.
2 Henrietta Barnett, *Canon Barnett, His Life, Works and Friends*, 2 vols, London, 1918, vol. 2, p. 160.
3 William Rothenstein, *Men and Memories*, London, 1931, p. 29.
4 Letters from Samuel Barnett to Francis Barnett dated 25 February and 11 March 1893, County Hall Archive.
5 Rothenstein, op. cit., p. 29.
6 Samuel Barnett to Francis Barnett, 3 September 1887, County Hall Archive.
7 Samuel Barnett to Francis Barnett, 25 February 1886, County Hall Archive.
8 Samuel Barnett to Francis Barnett, 12 April 1890, County Hall Archive.
9 Henrietta Barnett, op. cit., *Canon Barnet*, vol. 2, p. 155.

Chapter 8

1 Henrietta Barnett, 'Pictures for the People', from Samuel and Henrietta Barnett, *Practicable Socialism*, London, 1888, p. 113.
2 Samuel and Henrietta Barnett, 'Public Authorities and Art Collections', from *Towards Social Reform*, London, 1909, p. 228.
3 Charles Aitken, quoted in Henrietta Barnett, *Canon Barnett, His Life, Works and Friends*, 2 vols, London, 1918, vol. 2, p. 178.
4 Henrietta Barnett, *Canon Barnett*, vol. 1, p. 50.
5 Samuel Barnett to Francis Barnett, 20 April 1906, County Hall Archive.
6 Henrietta Barnett, *Canon Barnett*, vol. 2, p. 160.
7 Henrietta Barnett, 'Pictures for the People', p. 121.
8 Walter Besant, 'Art and Handwork for the People', paper, Manchester, 1885, p. 23.
9 Samuel Barnett to Francis Barnett, 5 April 1890, County Hall Archive.
10 Henrietta Barnett, 'The Poverty of the Poor', from *Practicable Socialism*, p. 20.
11 Samuel Barnett to Francis Barnett, 12 April 1884, County Hall Archive.
12 Henrietta Barnett, *Canon Barnett*, vol. 2, p. 160.

Chapter 9

1 Henrietta Barnett, *Canon Barnett, His Life, Works and Friends*, 2 vols, London, 1918, vol. 1, p. 349.
2 Ibid., vol. 1, p. 153, p. 216.
3 *Tower Hamlets Independent*, 23 April 1881.
4 *East London Advertiser*, 2 April 1887, p. 6.
5 *Tower Hamlets Independent*, 23 April 1881.
6 *Tower Hamlets Independent*, 23 April 1881, p. 3.
7 *East London Observer*, 4 April 1885, p.6.
8 *East London Observer*, 6 April 1895, p. 5.
9 *East London Advertiser*, 2 April 1898, p. 3 and *East London Observer*, 2 April 1898, p. 7.
10 *Tower Hamlets Independent*, 23 April 1881, p. 3.
11 *East London Advertiser*, 2 April 1887, p. 6.
12 *East London Observer*, 24 March 1888, p. 5.
13 *East London Observer*, 24 March 1894, p. 6.
14 *East London Observer*, 2 April 1898, p. 7.
15 *East London Advertiser*, 4 April 1896, p. 7.
16 *East London Advertiser*, 16 March 1901, p. 8.
17 *East London Observer*, 2 April 1898, p. 7.
18 *Tower Hamlets Independent*, 8 April 1882, p. 3.
19 *East London Observer*, 9 April 1892, p. 6.
20 *East London Advertiser*, 4 April 1896, p. 7.
21 *Tower Hamlets Independent*, 23 April 1881, p. 3.
22 *Tower Hamlets Independent*, 23 April 1881, p. 3.
23 *East London Advertiser*, 17 April 1886, p. 3.
24 *East London Advertiser*, 4 April 1896, p. 7.
25 *Tower Hamlets Independent*, 23 April 1881, p. 3.
26 *East London Advertiser*, 17 April 1886, p. 7.
27 *Tower Hamlets Independent*, 23 April 1881, p. 3.
28 *East London Advertiser*, 4 April 1896, p. 7.
29 *East London Observer*, 12 April 1884. For a full account of this speech see Frances Borzello, 'An Un-Noted Speech by William Morris', *Notes and Queries*, August 1978, pp. 314–16.

Chapter 10

1 *South London Press*, 28 May 1887.
2 *Echo*, 17 August 1891.
3 A. C. Bernheim, 'Results of Picture-Exhibitions in Lower New York', from 'Successful Attempts to Teach Art to the Masses,' *Forum*, July 1895.
4 Richard St John Tyrwhitt, 'The Religious Use of Taste', from *The Church and the Age*, eds. A. Weir and W. Dalrymple Maclagen, London, 1870, pp. 128–58.
5 'Art Notes', *Art Journal*, 1884, p. 319.
6 *South London Press*, 31 May 1890; 30 May 1891.

Chapter 11

1 Dr Werner Picht, *Toynbee Hall and The English Settlement Movement*, London, 1914, pp. 59–64.
2 *Bermondsey Settlement Magazine*, April 1896.
3 *Toynbee Record*, May 1895.
4 *Express*, 6 April 1895.
5 *South London Press*, 23 May 1891.
6 *South London Press*, 31 May 1890.
7 *Bermondsey Settlement Magazine*, April 1896.
8 *Bermondsey Settlement Magazine*, 7–22 May 1913.
9 Jane Addams, 'The Art Work Done by Hull-House, Chicago' from 'Successful Attempts to Teach Art to the Masses', *Forum*, July 1895.
10 *Tribune*, 24 June 1891.
11 *University Settlement Society Bulletin*, 1892.
12 Samuel Barnett to Francis Barnett, 23 April 1897 and 5 May 1900, County Hall Archive.
13 Walter Besant, 'Art and Handwork for the People', paper, Manchester, 1885, p. 22.
14 University Settlement Society, catalogue of the 1892 exhibition.
15 Edward King, 'A Word About the Exhibition', *University Settlement Society Bulletin*, 1892.

Chapter 12

1 'The Pictures at the People's Palace', probably from the *Pall Mall Gazette* 1888/9. Clipping in Queen Mary College archive.
2 *Pall Mall Gazette*, 31 March 1891.
3 'Art Culture in the East End', *Echo*, 7 September 1891.
4 Henrietta Barnett, *Canon Barnett, His Life, Works and Friends*, 2 vols, London, 1918, vol. 2, p. 161.
5 'Art Culture in the East End', op. cit.
6 Arthur Morrison, *A Child of the Jago*, (1896), London, 1969, p. 53.
7 *Pall Mall Gazette*, 31 March 1891.
8 Charles Booth, *Life and Labour of the People in London. Series 1. Poverty. East-Central and South London*, London, 1902, p. 66.
9 Henrietta Barnett, op. cit., vol. 2, p. 162.
10 'The Pictures at the People's Palace', op. cit.
11 *Echo*, 7 September 1891.
12 Henrietta Barnett, op. cit., vol. 2, p. 164.
13 Samuel Barnett to Francis Barnett, 17 April 1897, County Hall Archive.
14 Henrietta Barnett, 'Pictures for the People', from Samuel and Henrietta Barnett, *Practicable Socialism*, London, 1888, p. 114.
15 Sir Alfred George Temple, *Guildhall Memories*, London, 1918, p. 94.
16 Henrietta Barnett, 'Pictures for the People', pp. 119, 120.

Chapter 13

1 William Morris, *Architecture, Industry and Wealth*, London, 1902, p. 167.

2 William Morris, 'Art Under Plutocracy', from *On Art and Socialism*, John Lehmann, 1947, p. 139.
3 Ibid., pp. 132, 133.
4 Walter Crane, *An Artist's Reminiscences*, London, 1907, p. 262.
5 T. J. Cobden Sanderson, 'Of Art and Life', from *Art and Life and the Building and Decoration of Cities*, London, 1897, p. 6.
6 Walter Besant, *All Sorts and Conditions of Men* (1882), London, 1883, p. 139.
7 Henry James, *The Princess Casamassima* (1886), London, 1950, p. 355.
8 Jack C. Squire, *Socialism and Art*, London, 1907, p. 5.
9 Henry Holiday, *Reminiscences of My Life*, London, 1914, p. 459.

Chapter 14

1 Beatrice Webb, *My Apprenticeship* (1926), London, 1950, pp. 177–8.
2 Charles Booth, *Life and Labour of the People in London. Third Series: Religious Influences, London North of the Thames: The Inner Ring*, London, 1902, pp. 50–1.
3 Charles Booth, *Life and Labour of the People in London, First Series: Poverty, East Central and South London*, London, 1902, pp. 118–19.
4 Jack London, *People of the Abyss*, New York, 1903, p. 267.
5 Arthur Morrison, *A Child of the Jago* (1896), London, 1969, p. 54.
6 Ibid., pp. 56–7.
7 Henrietta Barnett, *Canon Barnett, His Life, Works and Friends*, 2 vols, London, 1918, vol. 2, p. 164.
8 *The Times*, 11 March 1896.
9 Clive Bell, *Landmarks in Nineteenth century Painting*, London, 1927, p. 21.

Chapter 15

1 Roger Hinks, 'Patronage in Art Today', from *Art in England*, ed. R. S. Lambert, Harmondsworth, 1938.
2 Robert Lyon, 'An Experiment in Art Appreciation', from *Art in England*, op. cit.
3 Julian Trevelyan, *Indigo Days*, London, 1957, pp. 94–5.
4 From 'Art for the People', report of the British Institute of Adult Education experiment in providing loan exhibitions in the smaller towns of England.
5 *Adult Education*, Journal of the British Institute of Adult Education, vol. 7, p. 275.
6 Ibid., p. 153.
7 'Art for the People' op. cit., p. 31.
8 *Adult Education*, vol. 22, p. 163.

Chapter 16

1 Arts Council of Great Britain, Annual Report, 1945–6, p. 16.
2 ACGB, AR, 1953–4, p. 7.
3 ACGB, AR, 1950–1, p. 25; 1955–6, p. 13; 1957–8, p. 23; 1963–4, p. 29.
4 ACGB, AR, 1951–2, p. 3.

5 ACGB, AR, p. 3.
6 ACGB, AR, p. 10.
7 ACGB, AR, 1962–3, p. 4.
8 ACGB, AR, 1966–7, p. 11.
9 ACGB, AR, 1968–9, p. 11.
10 ACGB, AR, 1976–7, p. 9.
11 Su Braden, *Artists and People*, London, 1978, pp. 3–4.
12 ACGB, AR, 1975–6, p. 7.
13 ACGB, AR, 1975–6, p. 10.
14 ACGB, AR, 1976–7, pp. 8–10.
15 ACGB, AR, 1978–9, p. 9.
16 Ibid., p. 9.
17 Ibid., p. 9.
18 ACGB, AR, 1973–4, p. 18.
19 ACGB, AR, 1975–6, p. 14.
20 ACGB, AR, 1982–3, p. 8.

Index